DIGITAL
PHOTOGRAPHY
MADE
EASY

Contents

▶ BASIC PHOTO-EDITING

▶ MORE ADVANCED EDITING

▶ SHARING PHOTOS

▶ PRINTING PHOTOS

▶ JARGON BUSTER

EDITORIAL NOTE

The instructions in this guide refer to the Windows operating system and Adobe Photoshop Elements 8. Where other software or websites are mentioned, instructions refer to the latest version (at the time of going to print). If you have a different version, the steps may vary slightly.

Screenshots are used for illustrative purposes only.

Windows and Adobe are American products. All spellings on the screenshots and on the buttons and boxes in the text are therefore spelled in US English. The rest of the text remains in UK English.

All technical words in the book are either discussed in jargon busters within the text and/or can be found in the Jargon Buster section on pages 216–20.

INTRODUCTION

Switching from a traditional film camera to a digital camera needn't be daunting. With this book you'll find simple, step-by-step instructions and advice for getting the most from your digital camera. Everything from choosing the right camera for your needs to taking the perfect shot whatever the occasion is explained in easy-to-understand terms.

Digital Photography Made Easy is designed to guide you through everything you need to know to become a competent user of a digital camera.

The early chapters give clear, jargon-free advice on the must-have features of today's digital cameras. There's also helpful advice on taking better photos, transferring photos to a PC and managing your photo collection.

Later chapters take you step-by-step through improving photos in photo-editing software, to sharing photos with friends and family, both online or through print, plus lots more.

You can work through the book chapter by chapter, dip into a specific chapter, or use the contents page or index if you need advice on a particular subject. Now you're ready to get the most out of your digital photography, let's get started.

Lei

15. FEB 11

18. MAR 11

26. APR. 11

28. MAY 11

17. SEP 11

25ᵗʰ oct

25/9/15

Get **more** out of libraries

Please return or renew this item by the last date shown.

You can renew online at www.hants.gov.uk/library

Or by phoning 0845 603 5631

Hampshire
County Council

First published in the UK in 2010 by Which? Books
Which? Books are commissioned and published by Which? Ltd, 2 Marylebone Road, London, NW1 4DF
Email: books@which.net

British Library Cataloguing in Publication Data
A catalogue record for this book is available from the British Library

Microsoft product screen shot(s) reprinted with permission from Microsoft Corporation.
Microsoft, Encarta, MSN, and Windows are either registered trademarks or trademarks of Microsoft Corporation in the United States and/or other countries.

Adobe product screenshot(s) reprinted with permission from Adobe Systems Incorporated.

ISBN 978 1 84490 105 0

1 3 5 7 9 10 8 6 4 2

The publishers would like to thank Sarah Kidner and the Which? Computing team for their help in the preparation of this book.

Images appear courtesy of Digital Visions, iStockphoto, PhotoDisc, Shutterstock and the author (see page 224 for further details)

Consultant editor: Lynn Wright
Project manager: Emma Callery
Designer: Blanche Williams, Harper-Williams
Proofreader: Kathy Steer
Indexer: Ben Murphy
Printed and bound by: Charterhouse, Hatfield
Distributed by Littlehampton Book Services Ltd, Faraday Close, Durrington, Worthing, West Sussex BN13 3RB

Essential Velvet is an elemental chlorine free paper produced at Condát in Perigord, France, using timber from sustainably managed forests. The mill is ISO14001 and EMAS certified.

For a full list of Which? Books, please call 01903 828557, go to www.which.co.uk, or write to Littlehampton Book Services. For other enquiries, call 0800 252 100.

SWITCHING TO DIGITAL

By reading and following all the steps in this chapter, you will get to grips with:

 The benefits of digital photography

 Differences between film and digital images

 How digital cameras work

Switching to Digital

WHY SWITCH TO DIGITAL PHOTOGRAPHY?

Moving from film to digital photography can be an exciting experience. Today's digital cameras offer a wealth of features and functions that make taking a great photo far easier than it is with traditional film cameras. It's also becoming nearly impossible to buy film cameras on the high street, with digital cameras accounting for the vast majority of camera sales.

But how do you know that you're ready to take the leap from film to digital? Many experts say that film offers potentially better picture quality, and that digital cameras can't match the warmth and quality of a photo taken with a film camera. But, today's digital cameras are more forgiving of mistakes and have lots of automatic tools to help avoid common problems.

Here are a few questions to ask youself to ensure that you're ready to make the jump from film to digital photography.

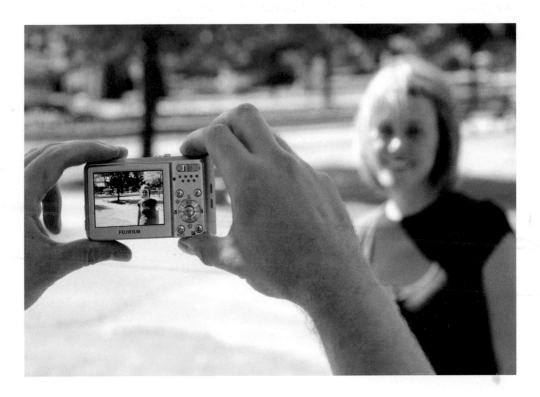

Does digital photography sound a bit technical and complicated?
It's true that many digital cameras have far more features and settings than film cameras, but many cheaper digital cameras are very easy to use and work in a similar way to your trusty 35mm film camera. One way to check you're ready to go digital is to borrow a friend's digital camera and try it out.

Do your photos sometimes not turn out right?
The difficulty with film photography is that you only get one chance to get it right. Once a photo is committed to film, you can't change it. Digital cameras often have lots of tricks to help avoid taking a bad shot, such as the ability to 'see' if a person is blinking, or even hold-off taking the photo until everyone is smiling. They can even be trained to recognise that there are people in a scene and ensure they're in focus.

Do you share photos with family and friends?
If the answer is yes and you are connected to the internet, then digital photography is a real time-saver. Digital photos can be sent to many people over the internet at the same time.

Would you like to take more photos?
It can be annoying when a film camera is running low on remaining shots because the film is running out. Digital cameras don't have this problem, with memory cards used by digital cameras able to hold more photos than hundreds of rolls of film.

Do you want to do more with your photos?
Not only do digital photos have the advantage of being able to be enhanced and changed using photo-editing software on a computer, as they're digital files you can do lots more with them. Options such as creating calendars, birthday cards, T-shirts and large canvas prints are all possible. Digital photography helps you do more with your images rather than simply sticking them into a photo album.

Switching to Digital

THE BENEFITS OF DIGITAL PHOTOGRAPHY

Using a digital camera saves time and money, and provides more options to use your photographs.

▶ Digital cameras don't use film, so you save money in both buying rolls of film and film-processing costs

▶ Digital photography is more environmentally friendly than traditional film, which uses chemicals in the development process that can have an environmental impact

▶ You can take as many photos as you want and see them instantly on the camera's display. If you don't want to keep a photo, you can simply delete it straightaway. This makes it easier to experiment and get the perfect shot without spending lots of money on film

▶ Printing options are often wider. You can connect your camera to a photo printer at home, print from your computer or at a shop photo kiosk, or print online through a print supplier

▶ You don't need to store negatives and prints. Once your photographs are transferred onto a computer they can be easily organised and archived. For extra safety, the photos can be stored on a CD, DVD or hard disk and then put away for safe keeping

▶ Once your photographs are on a computer, they can be easily shared using email or by uploading to a website that allows you to create and share virtual photo albums. Alternatively, you can put photos on a CD and post the disk to friends and family to view on their own computer

▶ Using photo-editing software, you can improve and alter your photos as much as you like. You can crop, resize, remove red eye, lighten or darken, adjust colours and correct flaws

▶ You can even be even more creative with special art filters that make photos look like paintings; add text to photos; or merge two or more images. Some digital cameras come with basic photo-editing tools or you can buy software online or at computer software shops

► There are lots of ways to display your digital photographs. You can create slideshows to view them on your computer or laptop; store and view photos on gadgets such as MP3 players that can show photos; and keep them on mobile phones. You can show your photos to a whole room by displaying them on a TV set or multimedia projector. You can also buy a digital photo frame that shows your pictures in a slideshow format

HOW DIGITAL CAMERAS WORK

At first glance, digital cameras look similar to traditional film cameras. Both types of camera have a lens, a viewfinder, a range of control buttons and share the same shape and size.

Digital and film cameras also use light passing through a lens to capture an image. When you press the button to take a photograph, an aperture opens at the front of the camera and light streams in through the lens. From this point onwards, though, the similarity ends.

To capture the incoming light, digital cameras use an electronic sensor called a charge-coupled device (CCD). It turns this light into millions of tiny digital squares.

View a digital image at extreme close up and you will see that it's made up of millions of these tiny squares of colour arranged next to each other on a grid. These squares are called pixels (an abbreviation of 'picture element'). When viewed at a normal size, these pixels form a recognisable image. The more megapixels an electronic imaging sensor has on your digital camera, the higher the camera's potential resolution.

What's in a pixel?

The more pixels a photo has, the more detail it will contain and the better it will look when printed.

▶ In this 10 x 10 pixel example, you can easily see and count the pixels

▶ As the pixel count increases, as in this 25 x 25 pixel image, you can just still see the pixels, but details of the photo become clearer

▶ In the original image (1,991 x 1,983 pixels), the pixels are too small and close together to view individually but the resulting image is recognisable as the face of a baby

Jargon buster

Megapixel
A measure of the size and resolution of the picture that a digital camera can produce. One megapixel equals one million pixels.

NEXT STEP ▶

For more on resolution – another important characteristic of a digital camera's description – see pages 24–5.

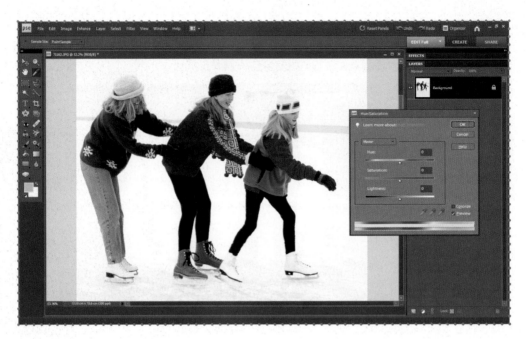

The digital part

Colour and brightness of each pixel is measured by the camera's sensor and stored as a number – albeit an extremely long one! It is because of these numbers that your photographs can be easily transferred to other digital devices, such as computers, photo printers and digital photo frames.

It is also because of this format that you can so readily adjust and edit your photographs after they've been taken using photo-editing software.

▶ Many digital cameras come with copies of photo-editing software, such as Adobe Photoshop Elements 8, and there are many packages available at a reasonable cost

▶ Once you've opened a photograph in a photo-editor, you can change it in lots of ways, including selecting and removing parts, resizing, and lightening, darkening and changing colours. Furthermore, you can see the photo on screen change as you edit or manipulate it

NEXT STEP ▶

There are some good free photo-editing packages, including GIMP. Give it a try by downloading it www. gimp.org. It comes complete with a user manual.

CHOOSING A CAMERA

By reading and following all the steps in this chapter, you will get to grips with:

- ▶ **Choosing the right camera for you**

- ▶ **Understanding resolution**

- ▶ **Selecting the camera features you need**

Choosing a Camera

TYPES OF DIGITAL CAMERA

Once you've decided to try your hand at digital photography, the next step is to purchase a digital camera and here you may face a challenge. There are lots of different types and models of digital cameras available, and if you don't know what to look for in a camera, it can be hard choosing the right one for your needs. Digital cameras can be divided into two broad categories:

▶ Compact digital cameras
▶ Digital SLR (single lens reflex) cameras

Pocket-sized compact cameras have fewer features than larger SLR cameras, but they're a fraction of the cost and more convenient to use. Despite the differences, all but the cheapest digital cameras are capable of capturing high-quality images, especially when used to create snapshot-sized prints.

Compact digital cameras

When shopping for a compact digital camera, you'll see several terms used to describe different types. They are ordered here from least to most expensive.

Compact/point-and-shoot The portability of compact digital cameras means you never have to miss those spur-of-the-moment shots. This is why they're also called point-and-shoot cameras. They come with fully automatic and scene modes – perfect for beginners – and some models include semi-automatic and manual controls for more advanced use. The price of these cameras is low to moderate.

Ultra-compacts These are the smallest compact cameras and are usually 20mm (3/4in) thick or less. The trade-off for their size is usually a lack of manual controls and sometimes a viewfinder. Buttons and dials can be fiddly to use, but ultra-compacts are capable of taking good quality images. The price of these cameras is moderate to high.

Prosumer cameras These are high-end compacts and bridge the gap between compact models and digital SLRs. Designed for the more experienced amateur photographer, they offer manual and semi-automatic controls as well as fully automatic modes. These cameras have high-quality lenses and some models can take add-ons such as wide-angle and telephoto lenses, filters, remote controls and external flashes. The price of these cameras is moderate to expensive.

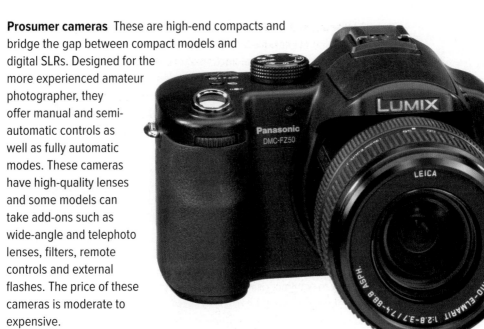

 # Choosing a Camera

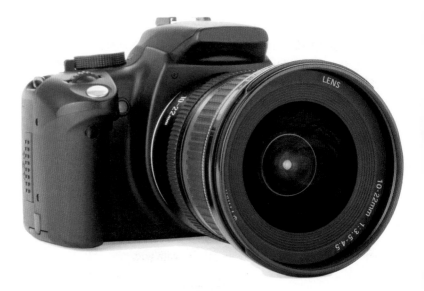

TRY THIS

Do some research before you buy. Read quality reviews of the latest models and ask friends with digital cameras for their advice. It's a good idea to try holding and using a camera in the shop before you buy.

Digital SLR cameras

Digital versions of traditional single lens reflex film cameras, these top-of-the-line cameras are used by professional photographers and skilled amateurs. The key difference between SLRs and compact cameras are:

▶ Digital SLR cameras have interchangeable lenses, so you can swap lenses to suit the style of photography or type of photo you want
▶ Digital SLRs have larger image sensors for better photo quality
▶ Compact cameras use electronic viewfinders, whereas with a digital SLR you view the scene through the lens itself so what you see is exactly what you get in your photo
▶ Digital SLRs have more advanced control over camera settings
▶ You can choose from a large variety of accessories to use with digital SLRs, including powerful flash units

These advanced features come at a high price, however. A professional level digital SLR can cost 10–20 times more than a compact camera and the price of professional-level lenses can be very expensive.

As with digital compact cameras, digital SLRs come in a range of options. Entry-level models usually have several automatic modes (similar to compact cameras) that helps makes them less intimidating for beginners. The price of these cameras is high to expensive.

ALTERNATIVES TO DIGITAL CAMERAS

Digital cameras are found in a variety of other technology gadgets – most notably mobile phones and camcorders.

Camera phones

From being a fun extra that allowed mobile phone users to send low-quality photos from one phone to another, phone cameras have evolved into a serious alternative to cheaper compact digital cameras.

With higher numbers of megapixels and greater resolution, better lenses and increases in storage capacity on mobiles, camera phones now offer a great way to ensure you have a camera on you at all times when you don't have your actual camera with you.

Digital camcorders

Many digital camcorders have a digital-stills option, which lets you use the camcorder as a camera. But don't be fooled into thinking this is a true alternative to a separate digital camera. While for the occasional shots a digital camcorder can capture a good-quality image, the camcorder's internal components are designed specifically for moving footage rather than still images.

GET THE RIGHT SIZE OF CAMERA FOR YOU

One technology trend that shows no sign of slowing is for manufacturers to keep developing increasingly smaller digital devices. From mobile phones, to cameras and camcorders, the size of these gadgets is a fraction of what they were decades ago.

Yet while tiny technology design looks great and is extremely portable, this is often at the cost of comfort and handling. This is particularly relevant for digital cameras. Being able to hold a camera comfortably and access all its buttons and controls with ease will not only see you use the camera more, but you'll be capable of taking better shots.

When shopping for a digital camera, physically try out a camera before you buy. Some cameras match your requirements on paper in terms of resolution and features but may not feel comfortable in the hand.

What to look for when choosing a size of camera

1 Check you're able to grip it properly, ideally with two hands to help avoid camera shake. If it is too small, it may be difficult to hold steady

2 Ensure your fingers don't obscure the lens or flash. This may seem obvious, but with small cameras there's less of it to hold onto

3 Make sure you're able to access the control dials and buttons with ease. Some ultra-compact digital cameras have tiny buttons, which may prove frustrating to use

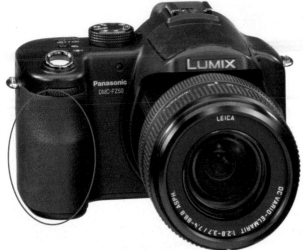

4 With larger cameras, in particular, check its weight is comfortable when using it for a length of time

5 If it has a grip, such as that on the left, look for one that has a rubber surface as there is less chance of slippage

LCD SCREENS

All but a few of the cheapest digital cameras have an LCD (liquid crystal display) screen (as shown below), which serves a dual purpose: it allows you to view and frame a scene before you take a shot and then view, delete or print photos once they've been taken.

TRY THIS

Options for setting up your camera and refining modes (see pages 48–51) are also shown on the LCD screen. They appear in the form of menus that you scroll up and down using the buttons on the back of the camera.

What to look for when looking at an LCD screen

Choose a camera with a large LCD screen of at least 5cm (2in) or greater as this will make the camera easier to use. LCD screens are difficult to use in extremely bright or sunny conditions, as the sun's glare makes it hard to see what's on screen. For these occasions, it's important to have and use a viewfinder.

VIEWFINDERS

As with traditional film cameras, the viewfinder is a little window in the digital camera body above the LCD screen that you can look through to view and frame a shot.

▶ With compact digital cameras, the viewfinder sits above (and sometimes to the side of) the lens. So what you see through the viewfinder window is 2.5cm (1in) higher than what the camera lens actually sees (known as parallax error). This isn't a particular problem when your subject is far away, as with landscapes, but when taking close-ups it becomes more evident – and explains why sometimes the heads of subjects sometimes get chopped off in photographs

TRY THIS

If you wear glasses, look for a camera with a diopter adjustment – this adjusts the lens of the viewfinder so you don't have to remove your glasses each time you take a picture.

▶ Digital SLRs use a viewfinder that's connected to the lens with a prism. This lets you see precisely what the lens sees

▶ Electronic viewfinders (EVF) also show the same view that the lens sees. They project the image shown on the LCD screen onto a tiny LCD within the viewfinder, so even on a sunny day you can use the EVF to take shots

Example of parallax error
▶ On the left is a shot composed as viewed through a compact camera's viewfinder. Due to parallax error, this is what the lens actually sees. The picture on the right shows how the photo appears when taken

 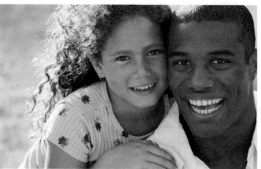

When to use a viewfinder instead of an LCD screen
While a large LCD screen is an advantage, using it to compose shots quickly consumes battery power. If it's important to conserve battery life, such as taking photos throughout a family outing or holiday, use the viewfinder for composing shots.

SENSORS

At the heart of your digital camera is a sensor that uses the light coming through the lens to convert and record an image as a digital file. There are two types of digital camera sensors:

▶ A CCD (charge-coupled device), which is usually found in digital cameras that produce high-quality images

▶ A CMOS (complementary metal oxide semiconductor), which is a newer technology that was initially used in cheaper digital cameras, but now can be found in more expensive compacts and high-end cameras. These smaller sensors work faster than CCDs and don't use as much battery power

When choosing a camera, you don't need to worry about what type of sensor it has, as many other factors are more important in achieving a great photograph. Sensor size, for example, can have an impact on image quality.

A larger sensor produces better photos, even in poor light conditions, as it can 'see' and record more light from the scene you're photographing.

ISO RATINGS

Digital cameras typically have an ISO rating – a series of settings that alter the sensitivity of your camera's sensor to light. Usual ratings on compact digital cameras tend to be at 100, 200 or 400. More advanced models will have ratings that go as high as 800, 1600 and even 3200. The higher the ISO setting, however, the more 'noisy' a photo will look.

TRY THIS

Some digital cameras now feature complementary metal oxide semiconductor (CMOS) sensors, which work in a similar way to CCD sensors.

choosing a camera

▶ The pictures to the right show that the higher the ISO rating, the more sensitive a camera is to light. The picture on the left is taken with a low ISO setting of 50; that on the right is 1600

▶ For well-lit scenes, such as a portrait taken outside on a bright day, a low ISO setting such as 100 or 200 would ensure your photo is properly exposed

▶ If you are taking a photo indoors on a gloomy day, choose an ISO setting of 800

▶ Auto modes on digital compact cameras will automatically pick the correct ISO rating for the photo you are taking. To manually set the ISO rating, access your camera's **Settings Menu**, choose **ISO** and change from Auto to the ISO rating of choice

Jargon buster

Noise
The digital equivalent of film grain, noise in digital photos appears as random speckles of colour where otherwise there should be a smooth surface. It can occur during the process of converting light into the digital numbers that define a photo.

UNDERSTAND RESOLUTION

Resolution is the most talked about digital camera characteristic and is often used to describe image quality.

A digital image is made up of tiny squares called pixels (see pages 12–13). The maximum number of pixels a digital camera captures in any one photograph is called the camera's resolution. This is usually expressed in terms of megapixels – or how many million pixels it can record in a single image.

For example, a digital camera that captures 2,048 (horizontal) x 1,536 (vertical) pixels produces an image with a resolution of 3,145,728 pixels (this number is achieved by multiplying the vertical and horizontal dimensions). That number is rounded by camera manufacturers, and the camera would be described as a 3 megapixel camera.

Why do I need high resolutions?
The advantage of having a camera with a higher resolution is that you have more pixels to work with, which matters most when it comes to printing photographs.

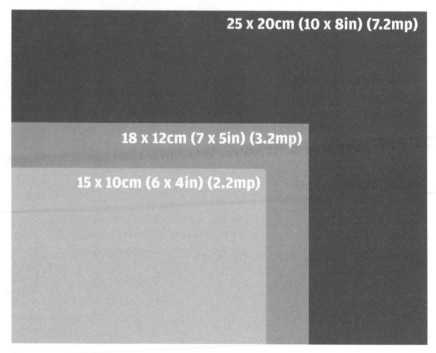

25 x 20cm (10 x 8in) (7.2mp)

18 x 12cm (7 x 5in) (3.2mp)

15 x 10cm (6 x 4in) (2.2mp)

The minimum resolution required to print pictures of different sizes

▶ The more pixels an image has, the more possible it is to print a detailed photograph at a larger size. Viewing your images on a computer screen is no indicator of print quality. This is because screens display images at 72ppi (pixels per inch), whereas to get a good-looking print you need to print on photo paper at 300ppi

▶ In a high-resolution photo you can use just part of the image for the final print or zoom into specific areas of the image. The more you zoom into or blow up a digital photo, the less smooth it will appear. By starting with a higher resolution photo, you can keep this jagged appearance at bay when zooming into part of a photo

Most compact digital cameras today boast resolutions of 12 megapixels or more, which offers all the resolution you need for most print options. At this resolution, you can print to A3 size or larger.

Are more megapixels always better?
While a digital camera's megapixel rating is important, it shouldn't be taken as surefire measure of image quality. Other technical factors, including lens quality, the size and type of sensor a camera uses and how it captures light and colour, play a vital part in achieving a sharp and clear photograph. In addition, there are a few drawbacks to choosing a camera purely on its megapixel rating:

▶ Higher resolution digital cameras are more expensive than lower resolution digital cameras. If you don't need to print photographs at large print sizes, then consider paying for what you will actually use

▶ Higher resolution digital cameras need more storage capacity in the camera. The higher the megapixels, the more space each image takes up on a memory card and the fewer photos you'll be able to store on each memory card

▶ Higher resolution digital cameras can be slower to take photos than lower resolution digital cameras. It takes more more time to process, compress (see page 26) and save a larger image

So consider how you use your photographs. If you resize your photographs once they're transferred to your computer to email them or upload them to online photo albums, then you can avoid this step by using a lower resolution camera.

Jargon buster

Jagged edges
When you view a digital photo at a high degree of magnification, the pixels that make up the image appear as tiny squares resulting in straight lines looking jagged.

Choosing a Camera

COMPRESSION SETTINGS

Most digital cameras compress photos before storing them on the memory card, so that each photo takes up less space. There are usually several different compression settings you can choose from and the higher the compression, the more pictures you can fit on a memory card.

However, while it's tempting to set your camera to use the highest compression level so you can store more images, in most cases, it's better to avoid this. High-compression settings (this might be labelled 'basic' or 'normal' on your camera) can introduce jagged edges in your photos. Lower compression, on the other hand, means higher quality photos and bigger file sizes.

▶ If you plan to print your digital photos on paper, select the highest resolution possible. If your intended use is purely emailing and online viewing, select a lower resolution setting in order to avoid huge file sizes

▶ Experiment with your camera's settings to find the compression setting that offers the best compromise of quality and capacity

▶ It's worth remembering that you can later shrink photos to a smaller file size by discarding pixels using a photo-editor (see pages 124–5). However, this doesn't work in reverse. Enlarging a low-resolution digital photo will simply result in a blurry image

JPEGs and compression

Most mid- to low-range digital cameras save photos to a memory card in JPEG format. This is a compressed file format that permanently and irreversibly loses quality each time the image is saved – basically throwing away some of your photo's pixel information. To minimise the amount of JPEG compression, select the highest resolution setting available on your camera.

LENSES AND ZOOM

A camera lens is an important part of digital photography as it controls how light is directed to a camera's sensor. Different lenses can make faraway objects look close up or keep a single object in focus while blurring the background.

How much magification a lens can provide is described as its focal length. The longer the focal length, the greater the magnification. A lens with a shorter focal length will be able to capture a wider view of a subject (such as a group shot). A lens with a longer focal length will see a narrower view of the scene, but at a higher level of magnification (better for distance objects).

Digital cameras come with different types of lenses
▶ The majority have retractable zoom lenses, which fold into the camera body when the camera is off and extend when it's on

▶ Others have fixed zoom lenses, which are fixed to the camera body and don't retract into it when the camera is turned off

▶ Smaller compact and ultra-compact digital cameras may have a fixed focal length lens with no real zoom capability

▶ Digital SLRs use interchangeable lenses so you can remove the lens from the camera body and replace it with another compatible lens

Get ready for your close-up
Nearly all digital cameras offer some form of zoom capability. This lets you focus on an object further away and make it appear larger without the need for you to physically get closer to it.

Using zoom makes for great candid people shots where the subject of your photos can remain relaxed and unaware of the presence of the camera. It's particularly good for snapping children busily engaged in activities or playing. It's essential for wildlife shots where getting close to an animal isn't practical or recommended.

Types of zoom
When choosing a compact digital camera, there are two figures to be aware of in relation to a camera's zoom capability – one for digital zoom and one for optical zoom.

Jargon buster

Focal length
Focal length lists the distance from the lens and the image sensor on a digital camera, usually in millimetres. Focal length determines the size your subject appears in a frame, and the camera's depth of field. Short focal lengths are good for wide-angle scenes, while long focal lengths are useful for taking shorts of distant objects. Most compact digital cameras have a 35mm equivalent focal length of 35–70mm, which is ideal for most everyday photography.

▶ Optical zoom is more important as it measures the actual magnification capabilities of a lens. A 3x optical zoom lens, which is the minimum zoom measurement for most digital cameras today, will magnify the image by three times

▶ Digital zoom merely enlarges the image after it's shot and often leads to photos losing sharpness as it increases the size of the pixels

What to look for when assessing the zoom

1 Ignore the digital zoom figure and look at the size of the camera's optical zoom

2 To check the zoom, most digital compact cameras have a button for accessing the zoom function. Press W to give a wide-angle shot, which will give you as much of a scene as possible in your photo

3 Press T for a telephoto shot. Telephoto allows you to zoom into your scene and focus on one part making it look as large as possible

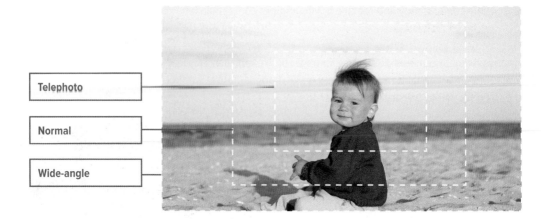

Telephoto

Normal

Wide-angle

BATTERIES

Your digital camera will need a source of power, and this usually comes in the form of batteries.

▶ Some cameras use custom batteries that are rechargeable so you won't face ongoing costs. However, these special batteries are expensive, so purchasing a spare battery or two can be costly

▶ Other digital cameras use conventional batteries – usually several AA or AAA-sized batteries – and often include a set of these when they are sold

▶ Conventional batteries can either be disposable batteries or rechargeable batteries. The advantage of digital cameras that use conventional disposable batteries is that should your rechargeable set run out, you can buy cheap standard replacements more readily

Battery tips

Cameras vary in the amount of battery power they consume and using the zoom, focus controls and the built-in flash extensively can shorten battery life significantly. In fact, they have a habit of running out at the most inconvenient moment – being unable to use your camera can ruin a family day out or a special occasion. To avoid this happening:

1 Check the battery level is high before you take your camera out for the day

2 Carry spare batteries with you when using your camera out and about

3 Consider buying a digital camera battery charger that you can plug into your car's cigarette lighter for charging on the move

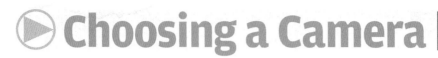

MEMORY CARDS

In conventional photography, film is essentially a storage medium and when one film is finished, you just take it out of the camera and pop in a new roll. Digital cameras use a form of removable digital photo storage called memory cards, which 'remember' your images until you delete them. The advantage of memory cards over traditional roll film is that stored photos can be erased and the card reused.

▶ Memory cards are relatively cheap to buy and come in a wide range of capacities

▶ Although cards are reusable, it's always good to have more than one. If you're going on holiday, for example, it's worth taking several memory cards with you in the same way you used to take several rolls of film

Size of card

Deciding what size of card to go for depends on how much storage space you're likely to require as well as the size of pictures you're taking (see pages 24–5). Also, as camera megapixel counts grow, higher capacity memory cards become necessary.

There's no definitive rule for the number of photos you can put on one card because different cameras compress images for storage in different ways and this affects the size of each file. Most camera manufacturers publish tables on their websites that show how many images you can save on their included memory card.

Types of memory cards

Most digital cameras come with a memory card, but it will most likely be a low-capacity card. So be sure to budget for an additional one.

▶ **CompactFlash cards** are one of the most common types of digital camera memory. They are cheap and widely available. Two different CompactFlash storage cards are used, termed Type 1 and Type 2. It is important to know which type of card the camera will accept as some cameras will work with one type but not the other. The maximum storage capacity of CompactFlash memory cards is currently 64GB

▶ **Secure Digital (SD) and MultiMediaCards** are the smallest of all memory cards and are usually used in ultra-compact digital cameras and devices such as MP3 players. They have less maximum storage capacity than CompactFlash cards but still offer enough space for most digital photography needs. The only difference between the two is that SD cards allow you to protect the data on them with a write-protect switch. The maximum storage capacity of MultiMediaCards is currently 32GB while SD is 2GB. A higher capacity SD card format is available: Secure Digital High-Capacity (SDHC) cards, which range in capacity from 4GB to 32GB

▶ **MicroSD cards** may be used in ultra-compact digital cameras. These are the smallest memory cards available; about the size of a fingernail, they are about a quarter the size of an SD card

▶ **xD Picture cards** have been developed by Olympus and Fuji for their own range of digital cameras, but they can be used in other makes of camera by using a CompactFlash adaptor. Measuring in at less than 2.5cm (1in) square, their tiny size means they can be used in very small cameras. They offer a maximum of 2GB of storage

▶ **Memory Stick** was developed by Sony and is used in nearly all Sony digital cameras. It can also be used in additional Sony devices such as MP3 players. Very few other cameras beside Sony cameras use them, so if you switch to another brand of camera at a later date, you may end up with an unusable memory card. Maximum storage capacity is 32GB

BE CAREFUL

Not all memory cards fit all cameras so make sure you choose the right one for your make of camera.

choosing a camera

NEXT STEP ▶

With some computers you can put your memory card directly into a special slot to upload your images – for more information, see page 97.

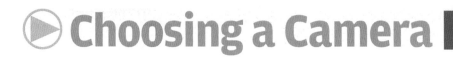

Choosing a Camera

OTHER FEATURES TO LOOK OUT FOR

Image stabilisation

Many compact digital cameras now offer image stabilisation (IS), also known as vibration reduction or anti-shake. This helps prevent digital photos from becoming blurred, which can be caused by your hand shaking, especially in low light conditions or when you're zoomed right in on an object. There are two type of image stabilisation:

▶ Optical image stabilsation, which is provided by a built-in gyro sensor and microprocessor that detects camera shake as it occurs and then compensates for any movement

▶ Digital image stabilisation, which simply boosts camera sensitivity to achieve a faster shutter speed to prevent blur. It is not as good as optical image stabilisation, so check when choosing a camera

Face detection

Face detection is a feature that most new compact digital cameras have. It helps you to take better photos of people without the hassle of adjusting focus and exposure settings yourself.

TRY THIS

Other new face detection features include a smile shutter mode, which shoots a photo of the subject when a subject smiles, and a blink warning that alerts you to shots in which a subject might have blinked.

▶ As cameras tend to focus on what's in the middle of the frame, a person standing nearer or further away can be out of focus because the camera focuses on the centre of the picture. Face detection, as shown below, can usually detect up to eight or nine faces in a frame, and will adjust the focus to ensure the best possible sharpness and adjusts the exposure to make sure the faces aren't too bright or dark

▶ Face detection also works in dim light, controlling flash strength for the best picture

Shooting modes

Many digital cameras have three shooting modes: single image (the default setting, which you will use most of the time), burst mode and self-timer.

▶ **The burst mode** lets you take a series of shots in fast succession – ideal if you're photographing something fast moving, such as a race car or a running animal

▶ **A self-timer** sets your digital camera for a delayed exposure, giving you around 10 seconds before it takes the picture. This is useful for including yourself in the photo or for low-light photos as it helps avoid camera shake caused by pushing the shutter button

TRY THIS

As well as shooting modes, there are also pre-set scenic modes on digital cameras. The most common of these are described on pages 48–51, but you may also want to see what other scenic modes are available on the cameras you are looking at.

Flash

Most digital cameras come with a built-in flash and flash modes that include automatic, on and off. Some cameras include additional flash options such as red-eye reduction for shooting people and animals.

If you need more power and flexibility, you may prefer to use an external flash unit. Only cameras equipped with an appropriate fitting known as a hotshoe or contact (see page 34) are compatible with external camera flashes.

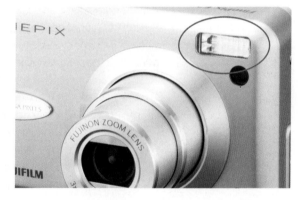

Video

Most compact digital cameras are able to capture video clips in addition to still images and more and more models can capture high definition-resolution video. However, if you're serious about video, the best quality will be gained from using a dedicated high-definition camcorder. Video modes in digital compact cameras are best for quick, low-quality use only.

NEXT STEP ▶

For more information about using the flash to enhance your pictures, see pages 66–7.

 # Choosing a Camera

ACCESSORIES FOR YOUR DIGITAL CAMERA

TIP
When buying a memory card reader look for multicard versions as they are more versatile.

Card readers

To transfer photos from your camera to a computer, a memory card reader is quicker than using a USB cable between the computer and the camera (see page 98). It also saves camera battery life.

▶ Memory card readers are cheap, starting from around £5

▶ Multicard readers can read many different types of card – useful if you have several cameras or electronic devices that use different types of memory card

External flash

Sometimes the flash on your digital camera might not be powerful enough for your needs – typically it will illuminate your subject within a range of only a few metres (feet). This is why, for example, most photos taken from the stands at night-time football matches come out looking foggy and unclear.

▶ Some cameras come with an attachment on the top, called a hotshoe, onto which you can fit an external flash. This gives you a bigger range and successfully illuminates subjects that are further away

▶ You can usually change the direction of the flash, too, for more control. You can swivel the head so the flash doesn't point directly at your subject, for example. This can sometimes help make the photo look more natural

Tripod and supports

Although the camera might be perfectly focused, sometimes when there's not much light, or if you've zoomed right in, your photos might turn out to be a bit blurry. This is the curse of camera shake. Putting the camera on a tripod is a good solution and there's plenty of choice of different sizes and weights. It's particularly helpful if you are shooting movies as well – video can be badly affected by any movement.

▶ Full-size tripods cost from about £15 up to hundreds of pounds

▶ If bulkiness is an issue, get a mini-tripod – these sit on a hard surface like a table top and are cheaper

▶ A monopod is another alternative – with one leg instead of three, these are portable and are especially popular with sports photographers, for example, who often need to move quickly around the field of play to follow the action

Camera cases and bags

Camera cases come in all shapes and sizes, from simple soft cases to trendy-looking backpacks with pouches galore. Choosing which one is right for you depends on what type of camera you have and what equipment you need to take the photos you want.

TIP
A small bean bag can be a useful support if you don't have your tripod with you.

▶ A soft case will keep your camera protected from slight knocks. If you've spent hundreds of pounds on a more advanced camera, protect it with a hard form-fitting case

▶ As you use your camera more, particularly on days out, you'll probably find you need something in which to carry extra batteries, memory cards and other accessories. Look for a bag that's big enough to carry everything you need but not so large it will be a burden

▶ Consider a waterproof backpack version if you're a walker or a rambler, or a larger bag with dividers if you use a digital SLR with different lenses and pieces of camera kit

choosing a camera

⊙ Choosing a Camera

BUYING CONSIDERATIONS

Here's a checklist of factors to consider when buying a digital camera.

- ► Decide how much you want to spend and then look at the models in that price range
- ► Think about what type of photographs you wish to take. From family snap shots to more artistic images, make sure the camera you buy is suitable
- ► Look for a small compact model if you need a camera that can be carried easily in a shirt pocket or a small handbag
- ► Try before you buy. Visit a shop and handle the camera you're interested in
- ► If you're interested in improving your skills, look at cameras that offer manual controls and features as well as fully automatic modes
- ► Shop around before you buy. You may be able to find the particular model you're interested in cheaper online
- ► If you've particular photographic interests, such as sports, wildlife or macro photography for extreme close ups, look for a digital camera that's suitable – most likely this will be a digital SLR
- ► Think about what you want to do with your photographs. If you plan to make large prints of the images you've taken, you will need a camera capable of high-resolution images. If you're more likely to send images via email and post them online in photo albums, resolution is less important

TRY THIS

Most digital cameras come with a USB cable, which is used to connect the camera to a printer or computer. It transfers data faster than previous methods and you can plug and unplug the cable without shutting down your computer (see page 96).

What's inside the box?

When buying a digital camera be sure to check that it comes with most, if not all, of the following:

- ► Cable for connecting the camera to a computer (usually a USB cable)
- ► Instruction manual for the camera
- ► CD with photo-editing software for use on a computer
- ► Safety strap (usually a wrist strap)
- ► Removable lens cap if the camera doesn't have an automatic lens protection mechanism
- ► Set of batteries
- ► Memory card

GETTING STARTED

By reading and following all the steps in this chapter, you will get to grips with:

▶ **Getting to know your camera**

▶ **Taking your first photos**

▶ **Understanding the different modes that cameras offer**

Getting Started

GET TO KNOW YOUR CAMERA

Now you've taken the plunge and bought a digital camera, the first thing you'll notice is that the size and shape of your new camera is similar to traditional film cameras. However, some of the controls may be unfamiliar, so here's a quick tour of common features on a compact digital camera.

On the front of your digital camera

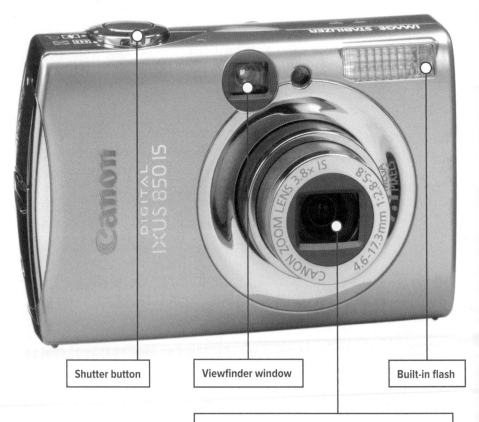

Shutter button	Viewfinder window	Built-in flash

Lens
The zoom lens shown here is extended. When turned off, the lens retracts into the body of the camera and is automatically protected from dirt, dust and fingerprints by a cap

On the back of your digital camera

1 Scenic mode dial (see pages 48–51)

2 Zoom control: zooms in (T) and out (W)

3 Menu gives access to all the camera's global settings

4 Flash lets you turn the flash on or off and select red-eye mode (see pages 66 and 67)

5 Timer mode enables you to get in the shot or take a picture in low-light conditions without shaking the camera (see pages 68–9)

6 Play puts the camera into playback mode, so you can view your photos and videos

7 Macro mode is great for taking close-up shots

8 Delete lets you dump the shot you don't want (see page 45)

9 Exposure compensation lets you notch the exposure up or down slightly

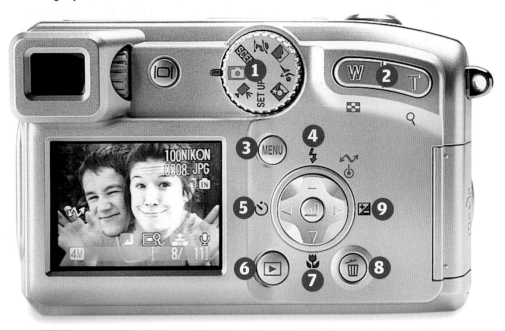

INSERT BATTERIES

All digital cameras use batteries to power themselves (see page 29). Some use traditional or rechargeable batteries while others take solid battery packs. Whatever type of battery your camera uses, make sure it is charged and inserted into the camera before turning the camera on.

1 Turn the camera upside down and look for the battery compartment door on the bottom of the camera

TIP
You will need to charge the batteries for a long time before their first use.

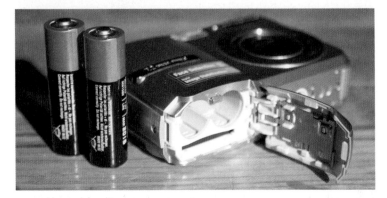

2 Open the battery compartment door by pressing a release button

3 Insert the batteries or battery pack. With a solid battery pack, there's only one way the pack will fit the compartment opening. If loading AA batteries, slip the specified number of batteries into the chambers, according to the plus and minus polarity marks that are on the camera

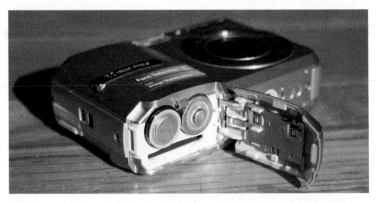

4 Close the compartment door firmly. The camera is now ready for you to use

INSERT A MEMORY CARD

Memory cards carry out the role that traditional 35mm camera film used to have for storing your digital photographs and video clips (see pages 30–1). To insert and remove a memory card:

1 Open the memory card compartment door

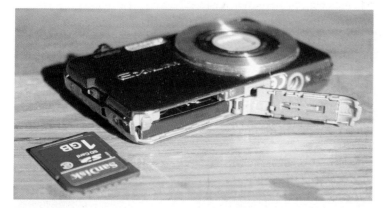

TIP
When buying a memory card look for one with a miminum size of 2GB. See pages 30–1 for more.

2 Hold the memory card so the connection end, which has a series of ridges, is pointing into the camera

BE CAREFUL

Don't force the memory card into the card slot – it will click when it is far enough in. It won't slide all the way in if it's the wrong way around.

3 Slide the memory card all the way into the card slot. The memory card can only be inserted one way

4 Close the compartment door

5 To remove the memory card, press the eject button next to the card or press the memory card until it pops out

⊳ Getting Started

TAKE YOUR FIRST SHOT

With a memory card and charged batteries inserted, you can turn on your camera.

Switch on your camera

1 Press the **Power** button on

2 The camera will make some whirring noises as it prepares itself for use

3 The retracted lens will open and may extend

4 The LCD screen on the back of the camera will be activated and will display what can be seen through the lens

Take your first shot

1 Make sure your camera is switched to auto focus mode

2 Hold the camera firmly and place your index finger on the shutter-release button, which is usually found on the top of the camera

3 Look through the viewfinder (if your camera has one) or use the LCD screen on the rear of the camera to compose your photo

4 Press the shutter-release button halfway down and hold it there for a second or two. This will focus the shot using the camera's auto focus mechanism and make it clearer

5 Fully depress the shutter-release button to take the photo. You will hear a sound that indicates that this has happened

6 The taken photo will appear on the LCD screen after a short pause. If you're not happy with the result, take another picture

NEXT STEP

Automatic mode sets the focus, exposure and light balance automatically. For other modes, see pages 48–51.

HOW TO KEEP YOUR CAMERA STEADY

Even the tinest amount of hand movement when taking a photograph can result in blurred and out-of-focus pictures. Here are some tips for keeping your camera steady.

▶ **Hold your camera securely** and close to your body. If using a compact digital camera, use your left hand to support the left-hand-side of the camera. If you're using an SLR with a long lens, support the bottom of the lens with your free hand

▶ **Take a stance.** Position yourself carefully to avoid body movement: stand with your legs approximately a shoulder-width apart and pull your elbows tight against the side of your body. When you're ready to shoot, take a deep breath, exhale slightly then hold your breath and press the shutter-release button to take the shot

▶ **Press not jab.** Press the shutter-release button gently and smoothly rather than jabbing at it

▶ **Brace yourself.** Rest your arms on a wall, bench or other hard surface. If there's nothing around that you can use, consider lying or sitting down, or bracing the camera against your knee

▶ **Use a tripod (see page 35).** The best way to keep a camera steady is to use a full-length tripod. Yet these can be cumbersome to carry around for lengthy periods, so look for other tripod options such as a mini-tripod or a small bean bag that can fit easily into a pocket

▶ **Use the self-timer** with a tripod. Combining tripod support with the camera's self-timer or a remote control cable ensures there's no hand movement involved in the actual taking of the shot

NEXT STEP ▶

If you don't like a digital photograph (perhaps it's blurred and out of focus), you can delete it – see page 45 for more.

VIEW YOUR PHOTOS

Once you have taken a photograph on a digital camera, it will appear briefly on the LCD. This is useful for seeing how the photo has turned out and whether you need to take another. Even if it has disappeared from the screen, it's easy to review your photos as they are stored on the memory card inside your camera. Here's how:

1 Switch the camera to playback mode by pressing the **Play** button, or moving the dial to the **Play** position (it looks similar to the play button on a video recorder) on the back of the camera

2 A photo will appear on the LCD screen, as shown below

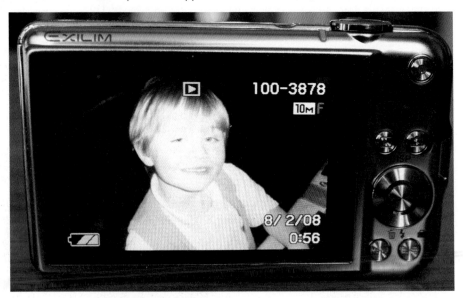

3 Use the scroll buttons to view your photos one by one. These are found on the dial on the back of the camera and are usually right to go forwards and left to go backwards through your photos. Some digital camera models use up for forwards and down for backwards instead

4 Some cameras allow you to zoom in and out of your photos using the zoom function so that you can get a close-up view of part of your picture

DELETE YOUR PHOTOS

One of the advantages of using a digital camera is that you can delete any photos you do not like directly from the camera. While different digital cameras use slightly different procedures for deleting photos, the basic approach is the same.

1 As soon as you've taken a photo it will appear for a short time on the camera's LCD screen. If you do not wish to keep it, press the **Delete** button. This is usually a button with the icon of a wastebin on it

2 If when reviewing your photographs, you decide you want to delete a photo, scroll to the photo in question

3 Press the **Delete** button

4 A message will appear on the LCD screen asking you to confirm that you want to delete this photo, or delete all photos on the card. Select **Delete this file** (or similar option specific to your camera) to delete just the photo you're currently viewing

BE CAREFUL

Most cameras offer the option of deleting all of the photos stored on the memory card. If you choose this option, make sure you've first downloaded the images to your computer or that you're certain you do not want them any more.

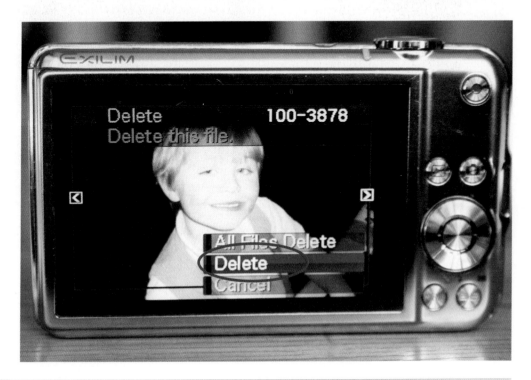

⏵ Getting Started

TIME DELAY

One of the main frustrations for traditional film camera users when switching to digital is the problem of time delay or time lag. Even though this is measured in just fractions of a second, it can significantly impact your photo and even mean you miss a shot entirely. There are three areas where time delay occurs.

▶ **Start-up time lag** This is the time it takes for a digital camera to be ready to take a shot from being switched on. Unlike film cameras, digital cameras need to activate their internal circuits when you first turn them on. This may only take a few seconds but it can be enough to make you miss a photo opportunity

▶ **Shutter delay** This is the amount of time between when you press the shutter-release button and when the photo is taken. Film cameras have shutter delay of around 0.1 seconds, while digital cameras shutter lag delays can range from 0.5 seconds to almost 2 seconds. This can dramatically affect photos of moving objects or people, particularly children, should they move or blink in that time

▶ **Cycle time** This is the time delay from taking one picture until the camera is ready to take the next picture. When a photo is taken, digital cameras need time to process, compress and store that image on the memory card. While you're waiting for this to happen, you cannot take another shot. Again this is usually a question of seconds or fractions of seconds, but it can be a problem if you want to take several shots quickly of a fast-moving object such as in sports photography

The good news is that manufacturers are continually reducing these time delays. The latest high-end cameras, such as digital SLRs, have virtually no lag times and react as conventional film cameras.

What you can do about it
Time lag can't be removed entirely, but you can help minimise it.

1 While it's tempting to turn off your digital camera between shots to save battery power, avoid this. Keeping your camera turned on all the time will avoid lengthy start up times. It may also have a 'sleep' facility, which you can set to different lengths of time. When the camera is 'sleeping' it conserves battery power, but is also quick to start up again

TRY THIS

Many manufacturers offer high-speed versions of their memory cards so opt for this if speed is an issue. High-speed memory cards record image data more quickly, which results in faster shot-to-shot times than using standard memory cards.

2 Choose a high-speed memory card as these store photos more quickly than standard memory cards, which means the camera will be ready to take the next shot faster. Speed is usually referred to as the read/write speed, and is a measure in megabytes per second (MBps) of how fast the card can process information

3 Anticipate the action. If you're photographing a moving object, try following it with the camera until you're ready to take a shot. Alternatively, focus the camera on a particular spot where action is anticipated and wait for it to happen

4 Take several photos in quick succession of the same subject. This is particularly useful when photographing moving objects such as cars or wildlife. It's also useful for portraits or group shots of people, who may blink or look away suddenly

5 Use lower resolution shots. Changing the compression setting (see page 26) on your digital camera to a high compression setting such as 'basic' or 'normal' will mean that the camera will compress and store photos quicker than a higher setting such as 'fine' or 'RAW'

TRY THIS

At a children's sports' day race focus on the finishing line to take the perfect shot of the winner as they race into frame.

NEXT STEP ▶

Use your camera's burst mode, if it has one, as this will take several consecutive photos while you keep the camera's shutter-release button depressed. See page 52 for more information.

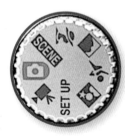

AUTOMATIC CAMERA MODES

For every subject you wish to capture, digital cameras offer a way to get the perfect photograph, through their scene mode settings. Many cameras use a mode dial (see left) only, while others combine the mode dial with additional modes accessed using menus on the LCD screen (see page 21) or buttons on the back of the camera. The number of scene modes varies according to the camera model you buy. The ones described here are the most popular.

Automatic

This is usually the default setting for most digital cameras. The icon on your camera may read as 'AUTO' or an 'A' icon. When in auto mode, all you have to do is point the camera and shoot the picture you want. The camera selects all settings, depending on the type of lighting and brightness of a scene. When there's not enough light, the camera automatically fires the flash.

Portrait

This mode is good for taking photographs where the subject is fairly close, such as people's faces. The camera selects a wide aperture setting that helps to blur out the background so you can focus in more on a person's face. In addition, the flash setting will try to switch to red-eye reduction.

Landscape

This mode is one used for any pictures you're taking of distant subjects, such as landscapes and mountains. Here the camera uses a narrow aperture to make sure as much of the scene you're photographing will be in focus as possible. This is referred to as having a wide depth of field.

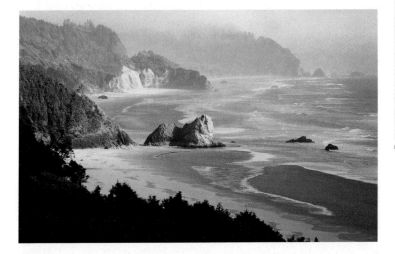

Macro

This mode is for taking photographs of subjects in extreme close-up, such as flowers, insects or other small objects, such as dew-drops on a spider web, as shown below. Choose this mode when you need to capture the tiniest of details on your subject. As you're close to the subject in this mode, any slight movement of the camera can result in a blurred picture, so use a tripod for best results.

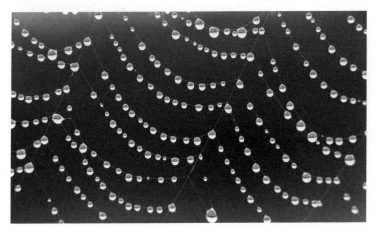

Jargon buster

Depth of field
The distance between the nearest and furthest in-focus objects in composing a digital photo. This is changed by altering the aperture. The larger the aperture, the smaller the depth of field.

Jargon buster

Aperture
A small, circular opening inside the lens that can change in size to control the amount of light reaching the camera's sensor as a picture is taken (see also pages 53–4).

NEXT STEP

Using manual modes, such as aperture size and shutter speed, are explained on pages 53–4.

Night

This mode is used for pictures you take at night or for any low-light conditions. The camera uses a slow shutter speed to help capture details of the background, but it also fires off a flash to illuminate the foreground (and subject).

Jargon buster

Shutter speed
A measurement of how long the camera's shutter remains open as the picture is taken (see also page 54).

Sports/Action

This mode is ideal for photographing any moving objects, including people playing sports, wildlife, car racing and so forth. The camera sets the shutter speed to its fastest mark in an attempt to freeze the action.

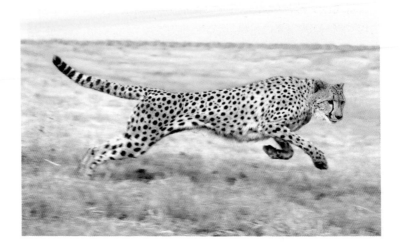

Beach/Snow

This mode is found on some cameras and is great for taking photos on the beach or in the snow where the bright and reflective surfaces can confuse the camera. Set to this mode, the camera will compensate for the abundant light by slightly overexposing the shot.

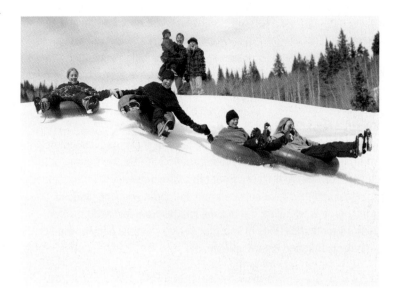

Other automatic scene modes

▶ **Sunrise/Sunset** helps capture the deep red and yellow hues seen in the sky at sunrise and sunset

▶ **Dusk/Dawn** help preserve the colour in the weak light of a scene just before sunrise or after sunset

▶ **Fireworks** is for shooting firework displays

▶ **Copy/Document** is for taking photographs of flat documents as it concentrates on only the white and black in the photo

▶ **Panoramic/Stitch** is for taking shots of a panoramic scene to be joined together later as a single image

NEXT STEP ⊙

Stitching together pictures is done during the editing process. See pages 167–8 for how to do this.

51

OTHER FEATURES EXPLAINED

Aside from the more common modes listed on pages 48–51, many digital cameras offer other modes to help take better photos.

Image stabilisation (IS)

Use this to avoid blurred images that result from shaky hands when taking a photograph. You can also use it when photographing a moving subject. It's best used when lighting is at a low level, such as indoors. Your camera increases its sensitivity to light, resulting in a shorter exposure time. The IS often does not have a significant impact when used in compact digital cameras.

Burst/Continuous shooting

This mode allows the camera to take several shots, one immediately after the other, until you take your finger off the shutter button, or the camera runs out of memory. Shot rates vary between different models, but most cameras take between one and three shots per second. Burst mode is useful for getting still images from fast action, when you're shooting pictures of sport, or perhaps even a baby or toddler – subjects that find it hard to keep still.

Flash auto/on

The built-in flash can be set to:

▶ **Auto,** which means it will fire automatically if needed

▶ **On,** which means it fires irrespective of the light levels. This is useful where you need extra light to take a good photos, such as when the the main subject is in shade. It can also be used as fill-in flash when the background lighting is very bright

Video

This mode lets you capture short video clips, usually with sound that's captured by a built-in microphone. The length of the clip may be limited by time or memory card space. Be aware that video consumes a lot of space on your memory card, so if you need to take longer, or indeed better quality, video sequence, invest in a video camcorder instead.

Jargon buster

Fill-in flash
Additional light from an external flash (see page 66) or a reflector (see page 65), which are used to brighten deep shadow area, usually outdoors on a sunny day.

GET CREATIVE WITH MANUAL MODES

Nearly all digital cameras are able to take perfectly good photos using automatic modes. Yet for more creative photography or if you want to take your skills to a more professional level, some digital cameras let you override automatic modes and manually choose settings. Many compact digital cameras have this functionality – as do all digital SLR cameras.

To get to grips with manual modes, you need to understand a bit about exposure. This is the process of capturing light with a camera to produce an image on a digital sensor. Your camera can control the amount of light hitting the sensor in two ways – through changing the size of the aperture and changing the speed of the shutter. The aperture and shutter both work together to produce correct exposures.

Aperture

Just as a human eye has a pupil that changes in size based on how much light is entering the eye, the aperture is an adjustable hole inside the camera lens that can be made larger or smaller to control the strength of the available light.

▶ **In automatic mode,** the camera's aperture adjusts automatically based on the amount of light entering the lens

▶ **When you use a camera's manual mode,** you can set the aperture to your own specification

Aperture size has an effect on the depth of field on a photo. If you have a narrow depth of field (see page 49), the subject will be in focus but the foreground and background will be blurred.

(see page 49)

TRY THIS

The size of the aperture, stated as a number, is called the f-stop and confusingly the smaller the f-stop number the wider the aperture.

Aperture and depth of field

 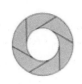

f2.8
wide aperture shallow depth of field

f5.6
wide aperture less shallow depth of field

f8
medium aperture normal depth of field

f11
medium aperture normal depth of field

f16
narrow aperture deep depth of field

f22
narrow aperture deeper depth of field

Shutter speed

The camera's shutter is a tiny mechanism that, like a door, opens and closes for a specified amount of time to allow the light entering the lens to expose the film. How long the shutter is open for is determined by the amount of light entering the lens. Shutter speed – the time the shutter is open for – is measured in seconds and fractions of seconds.

Shutter speed affects how clearly a camera captures movement. For example, taking a photo of a fast-moving object, such as a sprinter, will require a fast shutter speed. In contrast, with a slow shutter speed the aperture remains open for longer so the sensor records the light from an image for longer. This will produce a blurring of fast movement, which can be used to creative effect, as shown here.

Manual shutter modes available on some digital cameras

▶ **Program (P)** Program mode offers partial control over shutter speed and aperture

▶ **Shutter priority (TV/S)** Allows you to change the shutter speed for a particular shot and the camera adjusts the aperture accordingly

▶ **Aperture priority (AV)** Allows you to change the size of the aperture or f-stop and the shutter is calculated by the camera

▶ **Manual (M)** In this mode, you can set both the aperture and shutter speeds to suit your needs. This is for experienced photographers who want to explore different creative effects

TAKING BETTER PHOTOS

By reading and following all the steps in this chapter, you will get to grips with:

- **Taking photos in different light conditions**

- **Taking great family shots**

- **Taking better holiday photos**

UNDERSTAND COMPOSITION

It can be tempting to snap away with a digital camera, taking lots of photographs of a scene or event in the hope of a good shot. Yet a few moments spent understanding how composition – how you use a digital camera to frame a scene – can result in better photos.

Composing a good photo involves looking at the scene you're about to photograph and thinking about how the subject, background and positioning are all working together to create a pleasing photo.

Use the rule of thirds

Instead of framing the main interest point centrally in a photo, imagine that the scene is divided into nine segments by two equally spaced vertical and horizontal lines. Position the important elements of your photograph where these lines cross, such as the gondola jetty below. Some digital cameras can put a rule of thirds grid over the LCD screen.

TIP
For a more balanced photo, ensure the horizon is along a horizontal line.

Aim for balance and interest

Ensure the main object, such as a person, is off-centre in the photo – although this can leave a large expanse of empty space, it adds a sense of drama to photos.

Use lines to create interest and divide a scene

Known as the diagonal rule, photos where elements of the scene divide the photo diagonally are visually interesting. Try to ensure some elements, such as an object's strong shadow, cut the photo diagonally from one corner to the opposite corner. The human eye is also drawn along lines. By using lines in a scene – such as the river or tree trunks below – you can create a more arresting composition.

 # Taking Better Photos

Use natural frames

Create interest in your photos by using naturally occuring frames that can isolate the main subject and give context and focus. Natural frames include doorways, windows, trees and buildings. Using these will draw the eye to the main focal point.

TRY THIS

While angled shots are interesting, on the whole it is better to compose a photo with the digital camera level with the main subject in your scene.

Choose the background

Often by snapping away at a scene, the resulting photos have a main subject that's hard to separate from the background – digital cameras tend to flatten scenes, merging the main subject into the background. So seek out plain backgrounds and compose your photo so the main subject is positioned against as plain a background as possible. Ensure, too, that there are no distracting objects, such as plant pots, that look as if they are resting on heads.

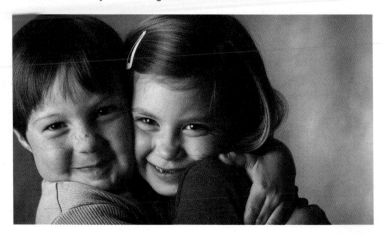

Get up close and use the full frame

Photos can look boring if the main subject is too far away, creating a photo that has lots of unexciting empty space around the subject. Try to get as close to your subject as possible, and fill the frame. For a more artistic effect, don't try to fit the entire subject into the frame, concentrate on a cropped close-up. When photographing a scene, it can be tempting to include everything of interest – main subject, interesting background, and more. Keep it simple, with one clear point-of-interest.

TRY THIS

Keep at least 1m (1yd) away from your subject. Any closer is most likely nearer than the focal length of your camera (see page 27) can adjust to, resulting in shots that are blurry.

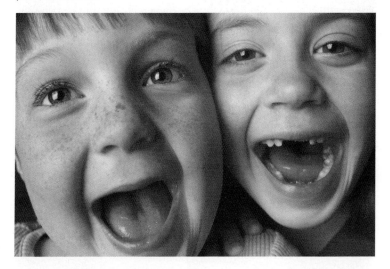

Choose an interesting angle

You can add drama and interest to a shot by capturing everyday photos from more interesting angles. A shot taken low down and aiming up past the main subject to capture a towering building, for example, is more exciting than a standard snap of the subject standing in front of a building. This technique also works well for creative group shots of people, especially children.

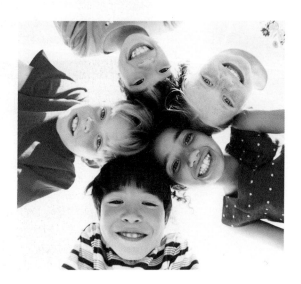

taking better photos

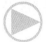

LIGHTING BASICS: BY DAY

The word 'photography' itself means 'drawing with light', and how your scene is lit will dramatically affect the final photo. Poorly lit subjects, overbright outdoor shots and murky indoor lighting can spoil otherwise perfectly composed photos. But, understanding a few lighting basics when using a digital camera can improve your photos.

Lighting when taking a photograph indoors

1 Let in as much light as possible by opening blinds and curtains but avoid photographing your subject silhouetted against bright light shining in from a window, shown below. The bright light will darken your subject, and draw the eye to the bright window pane instead, so take the picture with your back to the window

TRY THIS

If your camera allows you to alter its ISO (see page 23), then set it to around 100 for better, more detailed photos in low light.

2 Set your camera to **automatic mode**

3 Avoid using the flash as this tends to create stark shadows that are especially unflattering for family shots. It also washes out colour from the scene

4 If natural lighting isn't available, improvise with table lamps, candles and overhead lights, which provide direct and indirect lighting for a scene

5 Use a tripod or rest the camera on a steady surface because by setting the camera to auto mode and turning off the flash the shutter speed will be slowed right down

Get the balance white

Light always appears white to the naked eye. In fact, it takes different colours depending on the source; from household light bulbs to natural daylight. So a photo taken indoors by the light of a standard ceiling bulb may come out with a slight yellowish cast.

▶ Digital cameras have a feature called auto white balance, which ensures the 'true' colours (as our eyes would see them) are shown (see the image below left)

▶ Sometimes the camera struggles, though, especially with close-ups or scenes dominated by a single colour – the sky, for example. To counter this, there are manually selectable white balance settings, like daylight (for sunny days), cloudy (overcast days), or tungsten (for ordinary household light bulbs). White balance is usually automatically set by your digital camera when using auto or scene modes but you can also override them and the centre and right images below show how the same shot looks when using different white balance settings

TRY THIS

Some cameras have automatic settings as well for low-light conditions, such as birthday cakes lit with candles. Auto white balance and different settings can be found in the camera's setting menu.

Auto white balance setting

Sunlight white balance setting

Tungsten white balance setting

Lighting when taking a photograph outdoors

Avoid taking photos during the brightest part of the day, as an overly harsh sun can cast deep shadows, wash out detail and mute colours in a photo. Ideally, limit your photography to early morning or late afternoon, which has the advantage of softer shadows and warmer colours.

▶ At dawn, your picture will have a slight bluish colour cast

▶ At noon, colours will appear the most natural, although it might be too bright

▶ Just before sunset, pictures will take a lovely warm, orangey tone

LIGHTING BASICS: BY NIGHT

Photos taken at night are often disappointing, and taking good night-time shots takes lots of skill and understanding of your camera settings to ensure great photos.

1 Set your camera to **night/party mode**. This is a useful mode for taking pictures in low-light conditions as it keeps the shutter open longer when you press the shutter-release button to capture all available light in a scene

2 Turn off the flash. Unless the subject is very close, then it's best to override the automatic flash of the night mode. The resulting lighting is usually artifical and too harsh

3 Keep the camera steady. Due to the long exposures needed for successful night-time photography, it's worth investing in a tripod to keep your digital camera still. Any movement after pressing the shutter-release button and the photo being taken – which can be several seconds – can blur the image

4 Get your subject to keep still. If you are photographing a person against a night-time city street, for example, then encourage them to keep still. Night-time exposures are often measured in seconds and any movement during this time will blur them and consequently ruin the photo

5 To help further reduce camera shake, and if you are using a tripod, consider using the self-timer function to automatically capture the shot without the need to press the shutter-release button and inadvertently jog the camera (see pages 68–9)

TRY THIS

If your camera supports the RAW file format (see page 47), shoot night images in this rather than JPEG. It gives more options when editing them in a compatible photo-editing software.

For even better pictures

Night photography isn't characterised by a lack of light, but more about seeking out and using what minimal lighting is available.

▶ **Shooting at dusk** provides enough light to reduce blur, while still capturing the lights from buildings

▶ **A full moon** will enhance most outdoor night scenes, either by being part of the composition or just by adding more light to the overall scene. Check internet sites to find out moon rise times for wherever you may be

▶ **Use night portrait mode.** For taking night or low-light photos, most digital cameras have a night portrait (or similar) mode. This can be used for relatively slow-moving scenes of people, but won't be good enough for faster objects, such as fireworks. This mode usually triggers the flash at the start of the photograph to briefly illuminate the scene and capture more detail in the photo than normal

▶ **If you want to reduce your use of flash** even further, you could buy a small portable reflector, as shown below. This is a type of panel that bounces light on to your subject to remove distracting shadows. Experiment with controlling the surrounding light by positioning the reflector to one side of the subject's face

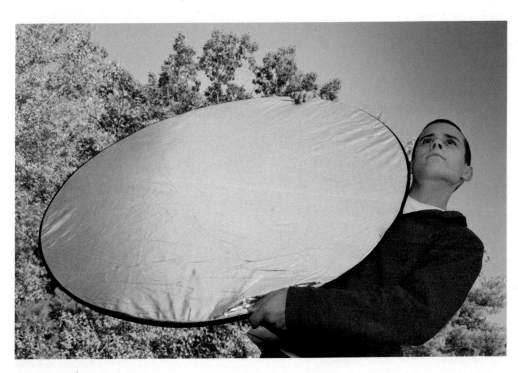

USING THE FLASH

Most digital cameras include a small flash that can be used when you have very limited lighting options. On the whole, camera flashes produce artificial-looking light, flattening the photo and creating harsh shadows around your main subject so avoid using the camera flash as much as possible

To use the flash

Either, set the camera to automatic mode. Most digital cameras will automatically trigger the built-in flash if you select automatic mode and the scene is poorly lit.

Or choose the flash type. Turn on the camera and press the **flash menu** button. Scroll through the options, which typically include:

TRY THIS

Place a small sheet of white tissue paper over the flash to reduce the amount of light and produce a more even coverage.

▶ Auto flash (see below), which tries to tailor the flash to the scene
▶ Flash off, which disables the flash
▶ Soft flash for reducing the harsh shadows created by a camera flash
▶ Red-eye reduction, which fires a series of rapid flashes before the picture is taken to elimate red eye

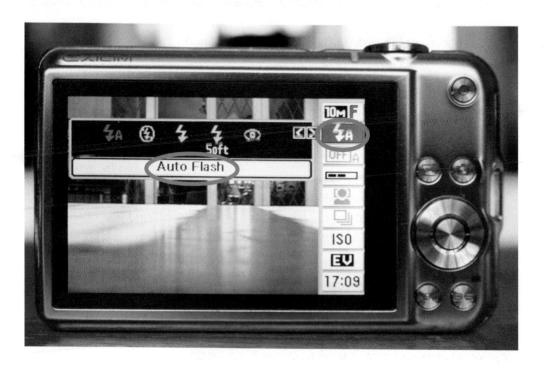

For even better pictures

▶ **Avoid red eye – without using red-eye reduction** If your digital camera lacks a red-eye reduction setting, you can prevent red eye when using the camera flash by ensuring that the subjects in the scene do not look directly at the camera when the photo is taken. More lighting in a room will also help to reduce red eye indoors

▶ **Know the limits of your flash** The built-in digital camera flash has a limited range. You can find this in the specifications section of the manual that came with your digital camera. The typical maximum distance is around 3m (10ft), so using the flash when taking photos in a stadium at night, for instance, will normally result in a brightly lit shot of the person's head immediately in front, and a dark scene of the actual event

▶ **Use fill-in flash** Using the flash outside, especially when your subject is silhouetted against a bright sky, can be an effective method for bringing out detail in areas that would normally be in shadow, such as faces. To be effective, remember that you should ensure your subject is within the range of your flash

▶ **Avoid reflections** Note where your main subject is positioned when using the camera flash. If you are taking a photo with the subject positioned against a mirror or window, the flash will bounce back and overexpose the photo. It will also create a concentrated burst of light on the reflective surface that will be captured in the photo

TRY THIS

On cloudy days, a fill-in flash setting can help lift the subject and make them stand out of the gloom. Choose fill-in flash if the subject is within 2m (2yd) – any further, and choose the full flash setting.

 # Taking Better Photos

USING THE SELF-TIMER

The self-timer is useful on a digital camera, as it allows you to compose your shot and press the shutter-release button, and then the camera will count down a set amount of time before taking the photo. This allows time, for example, for the photographer to move into the shot before the picture is taken.

To use the self-timer

1. Turn on the camera and press the **menu** button – the menu will appear on the LCD screen at the back of the camera

2. Referring to your camera's manual, find the self-timer setting. There are lots of options around setting a self-timer, including the amount of time you want it to count down from, usually in seconds, minutes and hours. Set the timer for 10 seconds

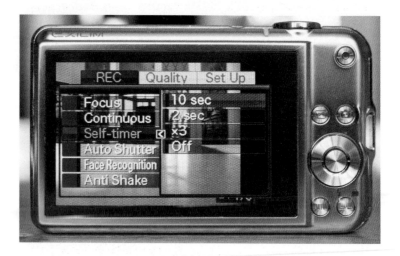

3. Position the camera so it will capture the scene using a tripod or resting it on a stable surface. Set the zoom and other settings to compose the scene

4. Press the shutter button halfway to focus the scene, then fully press the shutter to begin the countdown. The camera will flash as it counts down, allowing you to position youself in the scene ready for the photo

Getting the most from the self-timer

The self-timer isn't just handy for adding yourself to a photo, it can be used for creative effects such as time-lapse photography, where a series of photos are taken over a long time of a slow-moving event. Seen in sequence, they show a sped-up view of the event, such as a flower growing.

▸ **For time-lapse photography** position the camera and adjust the settings to take the photo. Set the timer on a tripod to take photos at set time intervals (such as each hour). Some cameras allow you to set a total time (such as a day) and set the number of photos taken during that period at regular intervals. Once done, press the shutter-release button to begin the timer

▸ **To use the self-timer for long exposure photography** set the timer to control the length of time your camera is taking for an exposure of a scene. Use this to, for example, set the exposure for 5 seconds to take a photo of a city street at night. The result will be a trail of car lights – remember to use a tripod for this type of photography

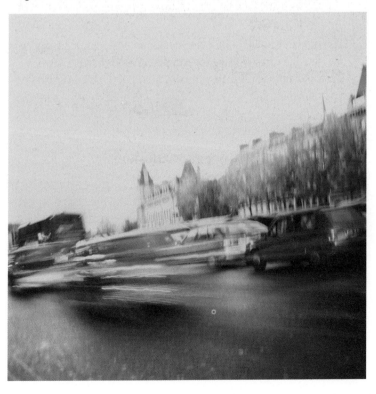

 # Taking Better Photos

FAMILY OCCASIONS

Get togethers of family and friends are an ideal time for capturing photos of memories that will last a lifetime. With some simple considerations, as outlined here, it's possible to take great photos of all types of family occasions.

TRY THIS

Go with the flow in choosing an angle to shoot from – try tilting the camera, shooting from a low angle or from the hip. Capturing the moment outweighs everything else.

Prepare for the event

1 The night before, double check the camera is fully charged, and that you have enough space on your memory card. A backup battery and memory card is a good idea

2 Set the mode. With lots going on, it's best to avoid fiddling with camera settings and risk losing out on that perfect shot. Set the camera to **auto mode**, or **party mode** if it has this. You'll miss fewer shots and have more time to focus on the party

3 Use a slower shutter speed if available (you'll need to manually set this on your camera) and keep the camera as still as possible. This will capture all available light without the harsh flash

4 Use the highest ISO setting on your camera(see page 23) where you feel the pictures have an acceptable level of noise. Most modern cameras offer great quality at 400 ISO, so that should be your minimum setting

5 If you have a built-in flash, make sure you get some distance – at least 1m (1yd) from your subject – so that you avoid the deer-in-the-headlight effect

6 If you have a separate flash unit, bounce it off the ceiling, or get yourself a flash diffuser to break up the directionality of the light. This will provide a more pleasant, natural look

For even better pictures

▶ **Set your camera to burst mode** (see page 52). This is a great way to end up with a series of shots that capture a range of actions

▶ **For more creative effects,** move the camera slightly when the shutter is released to create swirling light effects and streaks of colour

▶ **Use shadow to set the mood.** While it's generally best to avoid photographing subjects against a brightly lit plain background, the effect it has of throwing the subjects into shadow can create a more intimate photo – perfect for wedding and romantic celebrations

▶ **Get in close.** Empty-looking rooms with scattered subjects and dark, muted colours don't convey celebration well. Use the camera's zoom or, better still, physically get as close to your subject as possible, filling the frame. Don't be afraid to focus in on a single subject (such as a child with a present) as the main focal point

▶ **Make sure that the reason** for the celebration – such as graduation or birthday – is captured in your photos. This could be ensuring you have a crowd shot of graduating students throwing their hats, or position people so the celebration cake is visible in the background of some shots. If it is a birthday shot, then get in close to the candle-lit cake, disabling the flash to capture the cake all aglow

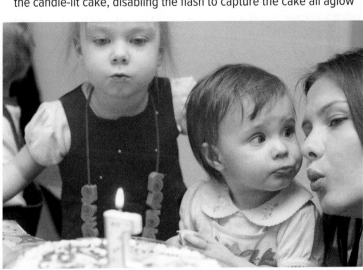

▶ Taking Better Photos

EVERYDAY FAMILY SHOTS

Great family shots are more than simply mastering your camera's controls. The trick behind great family photos is to make them look as natural as possible, conveying emotion and warmth, rather than awkwardness and the impression of having been artifically posed.

Put friends and family at ease

Relaxed photos are great photos, so get your family subjects talking to each other. Practical tips include:

▶ Positioning people naturally, with more natural groups (rather than, say, height order)
▶ Try to capture them in a familar environment where they are most at ease
▶ Try capturing candid action shots of everyday family life

Coordinate clothing

If you're aiming for slightly more everyday family photos, then help in the composition by:

▶ Ensuring clothing isn't a riot of distracting colours, patterns and logos
▶ Choosing clothing with the same tonal range (such as a range of different blues and whites)

Use props

Try to avoid this looking staged, but props can be useful in family photography.

▶ A much-loved toy can help a child feel more secure or distracted enough to have their photo taken
▶ Avoid big props as they can dominate the scene and steal the photo

Avoid cheese

Children and adults have grown up on the need to produce a phoney, on-demand smile when someone with a camera says 'Say cheese!' Natural smiles make for a great photo, phoney ones don't.

▶ If a smile isn't absolutely essential, then don't try to force one
▶ If you do need a natural smile, then take candid shots without the subjects being aware of the camera

Seek softer lighting

▶ Harsh sunlight doesn't just cast sharp shadows, it leads to squinting and distracted subjects. If the day is sunny, then group people together in a shady area and turn off the flash

▶ Flashes can also startle younger children, so avoid using it if possible when taking family shots

TRY THIS

Avoid using your flash as much as possible indoors. Most digital cameras have an option to turn off the flash when taking photos.

Get down to child level

▶ Children have a unique perspective on the world, and physically moving to their level by sitting or even laying down, can result in amazing shots of a child's eye view of the world

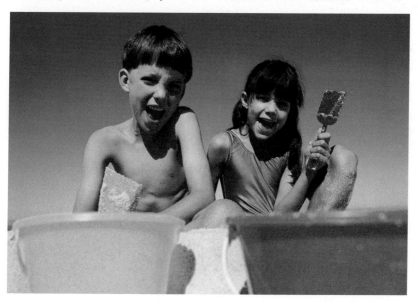

PORTRAITS: INDIVIDUAL SHOTS

Portraits of people make for great photos, and shots of individuals demand some different approaches to photographing groups.

1 If your subject is close to the camera (within 3m (10ft)), use the **portrait mode** setting. This will handle all the exposure and focus settings, allowing you to concentrate on taking a great photo

2 Preparation of your subject is important, especially for memorable individual portraits. Ensure you give the subject as much warning as possible, so that they can prepare themselves

3 Think about the background, choosing one that helps the subject stand out clearly. If you are trying to photograph something that says more about who the subject is, consider a background that contains some elements about their life, hobby or occupation

4 Ensure the subject is as far away from the background as possible, ideally by several metres (feet)

TRY THIS

Try to ensure that you don't position your subject against a similar-coloured background to the clothes he or she is wearing, or use a background with a distracting pattern.

5 Try to avoid taking full-body shots of your subject, as they will get lost as the focal point of the photo. Instead, set the zoom to its maximum, and step back to frame the subject. The long zoom and large distance between the subject and background has the effect of blurring the background, making the subject stand out more in the foreground

6 Set the camera to take the highest resolution. You can then further crop or enhance the photo in photo-editing software

7 Half-depress the shutter to focus on the subject's face, then fully depress the shutter to take the photo

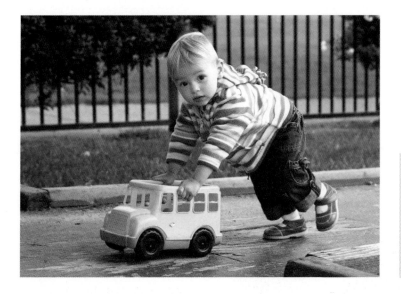

TRY THIS

Anticipate the action. It helps to factor in some space in front of a moving child when framing the scene, so you avoid cropping them when you press the shutter.

Photographing children

Taking portrait shots of children and grandchildren can be a challenge! One of the key challenges is keeping them still and natural looking, and avoiding a protrait looking staged.

▶ **For portrait shots of a young child or baby,** for example, work with a partner to help coo and coax a giggle or smile while you concentrate on the composition. Think about positioning the child against a plain-coloured background so nothing distracts from the star of the photo

▶ **Have the child hold onto something,** such as a toy, while you take the photo. This keeps the child from being too concerned about posing for the camera, and help some camera-shy children feel more secure

▶ **Children can move fast!** If you're trying to photograph quick-moving children playing in bright conditions, consider using the sports mode

▶ **Some of the best photographs** of children are unposed. When they are playing, for example, use the zoom setting to get a close-up shot. The whildren will be less aware of the camera, leading to more natural poses

Taking Better Photos

PORTRAITS: GROUP SHOTS

Family get-togethers and events such as weddings are a great opportunity to take memorable photos that will be treasured by all the family. By taking some time when you are preparing shots, and with a few tricks, it's possible to take great group photos.

Posing groups

Most people will automatically pose themselves in a group, or will adopt the highest-person-at-the-back school photo mentality. Instead of sticking to these fairly standard shots, a bit of organisation can pose the group differently:

 If the event is about one person or a couple (such as a wedding anniversary), make them the focus by positioning them in the middle of the group. To add variety, take a mixture of shots with the group looking at the focal subjects, at the camera, and with just the main subjects looking at the camera

2 Keep your group thin and not too deep, as it aids focus. If you are faced with a deep group, use the manual settings on your camera to choose a narrow aperture for a larger depth of field

TRY THIS

In general it's easier to take group pictures outdoors so if you have a choice, move everybody outside.

3 For more formal shots, keep tall people at the back and central, with shorter people at the edges of the scene. Also, ask people to lift their chins a little as it eliminates double chins!

For even better pictures

▶ **Group shots** with lots of people can be challenging to get right, with various subjects blinking, moving and being distracted. Switch your camera to burst/continuous shooting mode (see page 52). Hold down the shutter-release button and take a series of photos, then review them to check if you captured a usable photo

▶ **While using burst mode,** adjust the zoom by changing the focal length of the lens, taking a mixture of wide and tight shots

▶ **Use a tripod.** Not only will it help keep your camera steady, but will ensure you retain the camera's position – leaving you free to pose the group. Ensure that the camera is set-up on the tripod with correct focus, framing and settings, meaning you can quickly capture the right shot when the right moment arrives

▶ **Use unusual angles** to add drama

TRY THIS

Create your own family photo days. Shoot portraits of each family member on the same day each year. Or pick one day every month to do a quick photo shoot.

▶ **Frame the group.** Ideally, zoom in as tightly as possible and keep the camera positioned at eye level

ACTION SHOTS

School sports day and other sporting events can provide some great photos – but getting a photo that captures the action and is in focus can be a real challenge.

1 Turn on the camera and set it to **sport** or **action mode** (see page 48) to increase the shutter speed and lessen the chance of blurred photos. On the camera below, you use the scroll buttons to move to different modes

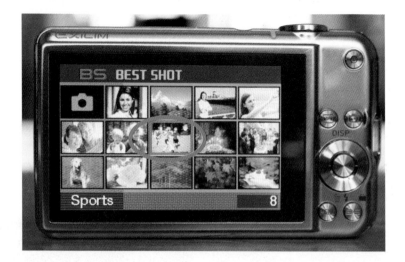

2 Disable the flash. You are unlikely to be close enough to the action for it to be effective – and it can also be distracting for those playing sport

3 Anticipate the action, giving extra space in the frame in front of a runner, for example. This will ensure that during the time it takes for you to press the shutter and the photo be taken, the main subject is still in the frame

4 Use auto focus lock, which is activated by half-depressing the shutter-release button and continuing to hold it half-pressed. By aiming the camera focus at the main subject, they will remain in focus as they move as long as you continue to half-depress the shutter-release button. Fully depress the shutter-release button to take the photo

For even better action pictures

Digital cameras come with a few extra features that make taking good sports photos easier, but some simple practical tips can also help.

▶ **Set the mode to burst** (or continuous shooting). After locking the auto focus on the main subject (see Step 4, opposite), fully depress the shutter-release button and keep it depressed. This will take a rapid series of photos, allowing you to capture the action

▶ **Get close to the action and at their level.** Sports day photos look far better if you ensure that the camera is at eye level with the main subject. Kneel down to take photos as this brings the viewer down to the level of the action and ensures better composition

▶ **Use a tripod.** Camera shake and blurred photos are a real problem for sports day photos. Invest in a tripod or monopod (see page 35), allowing you to get razor-sharp images of the action

▶ **It isn't just the taking part** that counts – photos of team celebrations and individual triumphs are a good addition. You can even take a few photos of the crowd to add context

TRY THIS

When shooting in continuous mode, shoot in JPEG format These are smaller files and mean you can fit lots more on your memory card.

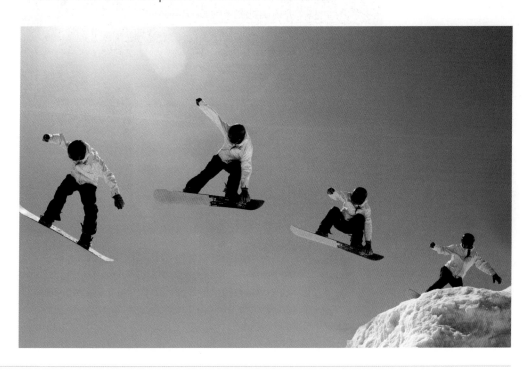

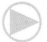 # Taking Better Photos

CLOSE-UP PHOTOGRAPHY

Close-up photography – often called 'macro' photography – used to be limited to those owning more expensive digital SLR cameras. But today's modern compact digital cameras can take very good close-up shots. These are great for getting close shots of flowers, animals and details of objects.

1 Select the **macro** or **close-up mode** (see page 48) – it is often shown as a symbol of a flower and means your camera can focus on subjects that are closer than normal. It has the bonus of using a large aperture setting, throwing the background out of focus

2 If your camera allows, adjust the aperture setting to be as large as possible (see page 53). This sets a very narrow depth of field, blurring everything but the main subject located at a very specific distance from the camera (see Step 4)

3 Set the flash to soft if it is an option, as using a full flash close to a subject will just wash out the photo. If you don't have soft flash, then ensure the flash is turned off

TRY THIS

Using a tripod means that you prevent camera shake and can change camera settings without losing the composition of the scene.

4 Turn off auto focus and manually use the adjustment keys (usually a '+' and a '-' or up/down arrows) to change the focus so your subject is clearly visible without any blur

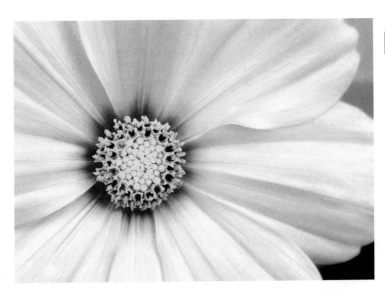

5 Think about composition. The rule of thirds and other composition techniques (see pages 56–9) still apply. Imagine how the eye will be drawn to elements in the picture, and compose the shot accordingly

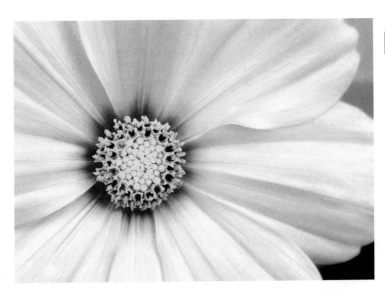

6 Take the shot and then review it to ensure the object is in clear focus, and reshoot if necessary

7 To get the best from close-up photography, it's a good idea to take lots of photos, changing settings such as focus (you may want to focus on the nearest part of the image, as here, or the furthest), viewpoint and aperture. A slight change can make a big difference when it comes to close-up photography – and it can be hard if your camera has a small LCD screen to accurately review your shot as in Step 6. Lots of photos can ensure a better chance of getting a good shot

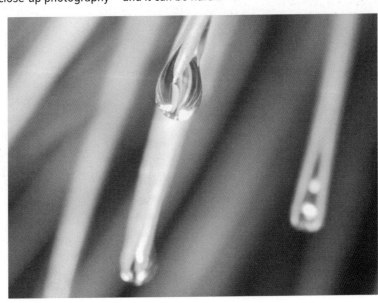

TRY THIS

Set the photo resolution to its highest when doing close-up photography so you can print your image at the largest possible size.

taking better photos

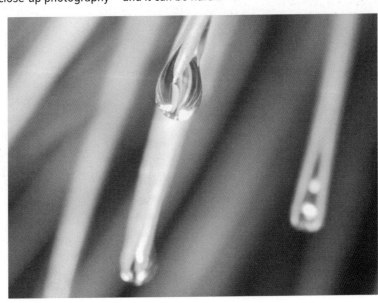

Taking Better Photos

ANIMALS AND PETS

Our pets can display the personalities of people – making them ideal subjects to photograph. The key to success is similar to that of portrait photography (see pages 74–5), but you'll need extra help with composing a shot.

1 Choose either **portrait mode** for general photos of a static pet, or as pets are often on the move, set the camera to **sports/action mode**. Portrait mode will throw the background out of focus and increase focus on the main subject, and sports mode will reduce shutter time, so you avoid blurred photos

2 Pets also suffer from red eye (and often green or yellow eye) in photos and digital cameras don't distinguish a pet eye in the same way as a human eye, so automatic red-eye settings aren't always effective. To combat red eye in pets, try to avoid using the flash, but if you have to use it, stand as far back as you can and take the photo on an angle, rather than directly aimed at your pet's face

3 Fill the frame for greater impact, as shown left. As with people, remotely positioning a pet makes for a lacklustre photo. Get close and fill the picture with your pet for greater impact, using the zoom to emphasise important elements

4 Depress the camera's shutter-release button halfway down, and keep it pressed halfway. In this way, you can lock the focus on your pet, even as it moves around. Press the shutter-release button fully to capture the photo when ready

For even better pet photos

Pet photos can be fantastic – and by following a few extra tips, you can get great photos of them in action that captures their personality.

▶ **Take lots of photos**. Even professionals will take lots of photos to ensure that perfect shot. With pets being unpredictable, you don't know what shot is just around the corner. Lots of shots means a better chance of finding a gem, like catching this cow at just the right moment

▶ **As animals are unpredictable,** try to anticpate their actions. Focus on a spot they are likely to run into (as with the centre of the shot below for the dog to bound into), pressing the shutter-release button as they enter the frame for a better chance of capturing a good shot

Taking Better Photos

TRAVEL PHOTOGRAPHY

Travel is one of the biggest reasons why people buy a new digital camera. The chance to see the world and bring back photos to evoke memories of the journey means that with a few simple tips your travel photography can be something that will hold memories for a lifetime.

Before you travel

▶ Make sure that you pack your camera equipment carefully, ideally in a camera bag. A padded camera bag with lots of compartments for storing extra memory cards and a backup battery will avoid a trip to a local shop to hunt down camera accessories at often high tourist prices

▶ You'll also need the camera battery charger, and an electric plug-socket convertor if travelling abroad

▶ Take time to research the location and jot down a short photo list of key events or places to photograph

▶ Read your camera's manual again to ensure you are familiar with its operation

When you're there

▶ Keep an eye out for the unusual, especially if it captures the location well. Locals make perfect subjects, but do ask permission first, and ask them for their advice on interesting subjects to photograph

BE CAREFUL

Always carry your camera as part of your hand luggage when travelling by plane to reduce the risk of losing it.

▶ Many people talk about the food their enjoyed on holiday, so keep a holiday food diary and photograph delicious plates of local cuisine

▶ Tell a story. Travel photography is more about the journey than the destination. Use your camera all the time from the moment you depart until you arrive back home to tell the story of your adventures. The small details matter: tickets to museums, ice creams and café menus all add to the story

▶ Photo opportunities can arise without warning when travelling, so keep your camera close. Also, familiarise yourself with different settings so you can quickly take the best photo possible in all situations – in this case a night-time street shot of lit paper lanterns

TRY THIS

If you have access to a computer and internet connection when travelling, consider uploading your photos to a photo-sharing site such as Flickr (see pages 185–7) as a back up to minimise the chance of losing precious holiday photos.

 # Taking Better Photos

ON THE BEACH

Beaches conjure up wonderful holiday memories and convey the huge amount of fun that's to be had while paddling in the sea or sunbathing on the sand.

1 Choose a **beach mode** if possible. It is also sometimes labelled **snow mode** and is usually a split-diagonal icon showing a beach and snow scene. This mode compensates for the extra bright conditions by slightly overexposing the photo

BE CAREFUL

For added protection, store spare memory cards and batteries in clear, sealable zip-loc-style bags to prevent sand from getting to them.

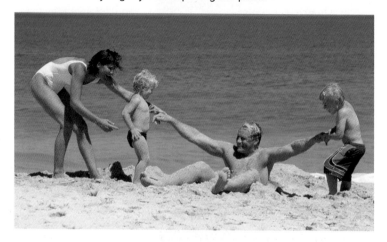

2 Alternatively, use **sports/action mode**. This reduces shutter exposure times, limiting the amount of light captured. It's also great for capturing shots of crashing waves, splashing friends and family, and water activities

3 Aim to photograph beach scenes either early morning or late afternoon, where the light is richer and contrast is lower. If you shoot between midday and 3pm the strengh of the sun can wash out images

4 Choose your location. Standard shots taken of the beach from your sunlounger or deck chair do not do justice to the location. Consider heading down to the water's edge and getting your feet wet. The wet sand at the water's edge is often free of distracting footprints and tyre tracks, and the wet sand adds a reflective lighting effect to any scene

5 Beaches can be empty and devoid of interest, so look for focal points. Interesting objects, patterns and shapes, like the kite, right, are good bets, as are beach-specific points such as sand castles and beach toys

Before you go

Beaches and cameras don't mix well – salt water and sand can play havoc with a digital camera. So follow some simple tips to ensure your beach photography is trouble-free.

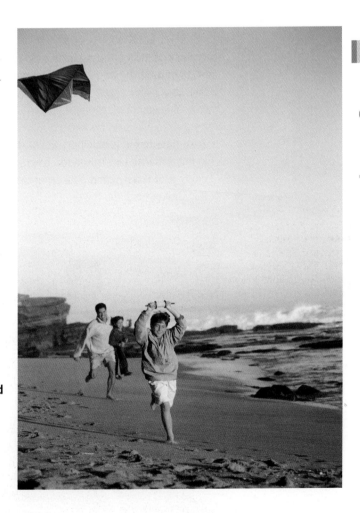

▶ **Only take what you need** to the beach, rather than bring an entire camera bag of equipment

▶ **Keep maintenance to a minimum.** Ideally, you shouldn't need to swap batteries or memory card on the beach, so ensure it is fully charged and you have enough spare space on your memory card before you head off. If you do need to change either, do it away from water and in a place sheltered from the wind

▶ **If you go swimming in the sea,** try to clean your hands with fresh, unsalted water before using your camera to avoid it getting salt from the sea onto the camera. Similarly, clean your camera with a soft cloth after going to the beach to remove any grit, sand and salt

Taking Better Photos

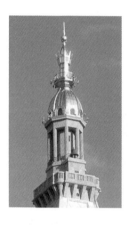

LANDMARKS

Landmarks can signify travel and catalogue your visits to different destinations. And, while taking a straightforward snap of a landmark is fine, using your digital camera to its fullest will create some truly memorable landmark shots.

▶ **Take time to explore.** Often, the best pictures aren't taken looking at the entrance to a landmark. Take some time to look around (and enjoy your visit!) to find unusual angles and compositions, such as this shot of the Eiffel tower

TRY THIS

For a more unusual shot, use the zoom to get closer to interesting parts of a landmark, as shown above.

▶ **Same shot, different light.** The same photo of a landmark can be a dramatically different shot at different times of the day, and in various weather conditions. The same landmark surrounded by cloud makes an interesting contrast to the usual sunny, smiley tourist shots

▶ **Put it in the background.** Often, photography of landmarks is all about taking a photo of the landmark itself, which can make for a dull photo. Instead, consider heading further afield and taking a photo with a different main subject – such as family or friends – with the landmark making up part of the background

▶ **Candid pictures** of people at landmarks – people jogging by, backpackers congregating, friends chatting or local people going about their daily lives – taken alongside a landmark can make for a more engaging story and intimate photo

 # Taking Better Photos

LANDSCAPES

Landscapes can be breath-taking vistas and make for a memorable photo. Landscape photography isn't about taking a snap of a scene, but the chance to capture a truly impressive photo.

1 Set up your camera to **landscape mode**. This will set the camera to its smallest aperture setting, maximising the depth of field of the image and so ensuring that as much as possible of the landscape is clearly in focus

2 Turn off the flash. Compact digital camera flashes are not powerful enough to have any impact on a landscape shot, but can over light immediate foreground objects

3 If possible, keep the camera steady using a tripod or monopod (see page 35), or ensure you are holding the camera extra steady. You can rest the camera (or your elbows if you are holding the camera) on a solid object, such as a wall

BE CAREFUL

When using panorama or stitch mode, some digital cameras achieve this effect simply by cropping the top and bottom of a standard photo. See pages 166–9 to discover more about stitch mode and panoramic techniques.

4 Consider using **panorama** or **stitch mode,** which are designed to take extra-wide shots of a landscape

5 Take lots of overlapping photos. Press the shutter-release button halfway to focus on each part of the scene, then fully press it to take the photos

For even better landscape pictures
Follow these handy tips to take great landscape photos.

▶ **Take a photo whatever the weather.** As the weather can change minute by minute, choosing the right moment to take a landscape photo is vital. Don't stick to only sunny days; consider photographing landscapes in a variety of weather condition from storms and mists, to gathering clouds and rain. Each variation will hep you create a more interesting landscape photo

▶ **Go wide.** Wide-angle lenses are commonly used for landscapes because they allow you to include more of the scene in the frame. If you're using a compact camera set your camera mode to landscape

▶ **Change your point of view.** For a more interesting landscape shot, experiment with different viewpoints of a scene. High vantage points give you a commanding view of the surrounding landscape while getting down low to the ground gives an unusual perspective

▶ **Maximise your depth of field.** If you're using a digital SLR or a camera that offers manual modes, experiment with small aperture settings. This will give images a wider depth of field so that more objects in both foreground and background will be in focus. Remember, smaller apertures mean less light is hitting your image sensor, so you will need to compensate either by increasing your ISO (see page 23) or lengthening your shutter speed or both

▶ **Use a tripod.** This help reduce camera shake, particularly when taking photographs at slower shutter speeds, and it forces you to slow down and concentrate on the scene you wish to photograph

▶ **Shoot in RAW.** If your camera is capable of it, shoot RAW images rather than JPEGs. While RAWs files take up more room on your memory card, the high quality they provide offers more scope for later image manipulation in a photo-editor

▶ **People your landscapes.** Landscapes can be beautiful, but sometimes including people in a shot can introduce a much-needed idea of the scale of the scene

MANAGING YOUR PHOTOS

By reading and following all the steps in this chapter, you will get to grips with:

- **Connecting your camera to your computer**

- **Organising your photo collection**

- **Backing up and protecting your digital photos**

 # Managing Your Photos

LOOK AFTER YOUR PHOTOS

Taking photos with a digital camera is quick, easy and fun. Before you know it, you'll find yourself with memory cards that are too full to use and hundreds of photos cluttering up your computer desktop or picture folders. With a jumbled mess of photos, it can be hard to find that special picture of a precious family moment or favourite acitivity that you may have taken a few months ago. So, here are some simple tips to help you organise your digital photo collection.

Transferring your photos to a computer

▶ Get your photos onto your computer as soon as you've finished taking a group of shots, say of a family day out, or when your memory card becomes nearly full. Then you can delete the images from the memory card if it's becoming full

▶ Your precious photos are now safely on your computer hard drive and your memory card will have plenty of storage for when you next want to use your digital camera

Keeping photos in one place

▶ Decide on a place to store your digital photos. This could be in Windows My Pictures folder, or another folder, or even an external hard drive

▶ Wherever you choose, keep all your photos in that one place, rather than scattered in different folders around your hard drive

Using a logical folder system

Having decided on a location to store your photo collection, the next step is to use a folder system in which to place photos. There are lots of ways to set up and label folders but consistency is the key to a successful system. A good folder system makes finding specific photos at a later date much easier.

▶ A simple solution is to create folders for each year, and then create subfolders for each month

▶ Alternatively, you could label your folders by events such as holidays or birthdays and then use subfolders for specific events such as Lake District Trip 2010 or Uncle Bob's 60th Birthday Party

Renaming your photos

Renaming your photos to something more meaningful will help you find photos at a later date.

▶ This can be very time consuming and tedious, but you can rename batches of photos quite easily in Windows or in a photo-management tool such as Adobe Photoshop Elements 8 (see pages 102 and 106)

Using tagging

Tagging is a great way to help manage your photo collection. A 'tag' is a word or short phrase that you link to a photo to help a search program quickly find that photo later.

▶ You can use any words you like. For example, you could add a tag to a photo of your friends Mary and John at their wedding anniversary celebrations in York using the keywords 'York', 'Mary', 'John' and 'anniversary' and then be able to search for all photos with these tags, no matter what folder they're in or what their name is

▶ As with renaming photos, adding tags can be time consuming, although the benefits of doing this pay off later. You can, however, add tags to multiple images (see pages 102–3)

Backing up photos

With your entire photo collection housed on your computer, it's wise to make regular backups in case of hard-drive failure or other computer malfunctions. It's cheap and easy to burn photos onto a CD or DVD and most desktop computers and laptops come with CD/DVD burning software (see page 111).

Using a photo-management tool

Consider using a photo-management tool to help organise your photo collection. Windows 7 users have Windows Live Photo Gallery but there are many free photo programs available such as Google's Picasa. Most of these programs offer tagging, renaming and backup functions, as well as basic photo-editing.

TRY THIS

Don't waste computer storage space on photos you're never going to use or those you consider to be poor quality or duplicate shots. Simply delete these.

managing your photos

EQUIPMENT FOR TRANSFERRING PHOTOS

Once you've taken a number of photos with your digital camera, the next step is to get them onto your computer so that you can edit, share and print them. There are a couple of ways to transfer photos from a digital camera.

Connecting your digital camera directly to a computer

The first step is to connect your camera directly to a computer using a connecting cable. This is normally a USB cable, although a few cameras use a FireWire connection instead. Most digital cameras are sold with a USB cable, so check the box it came in to find it. If not, you can buy one at any high-street electronics store for around £2.

1 As a precaution, make sure your digital camera is turned off before connecting

2 Connect the small end of the cable to the digital camera

3 Connect the other end to your computer's USB port

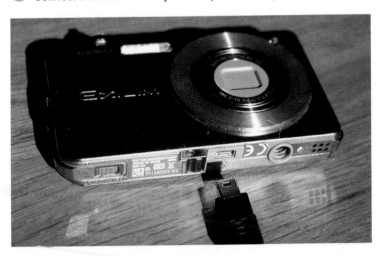

4 Turn the camera on and your computer should recognise that it is connected to the camera and will show it as a hard drive. On a Windows PC, a window should appear asking you if you wish to download photos from the camera. The type of window that pops up will depend on the system your computer uses and if you have any image-editing software installed

Jargon buster

USB (Universal Serial Bus)
A way of transferring data to and from digital devices, such as as digital cameras and computers.

Jargon buster

FireWire
Technology for transferring data to and from digital devices at high speed. Some professional digital cameras and memory card readers connect to the computer over FireWire. FireWire card readers are typically faster than those that connect via USB.

Transferring photos directly from your memory card

Some computers and laptops have a card reader slot and you can insert your memory card here to quickly transfer the photos to your computer. Look for a memory card slot on the front of your computer or on the side of your laptop.

1 Remove the memory card from your camera and insert it into a card reader slot on the front of the computer. Be careful when inserting it; you shouldn't have to use force

2 The memory card will appear as an icon on the desktop and a box will pop up as in Step 4 on page 96

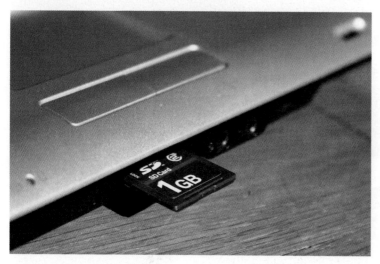

Jargon buster

Dialog box
A window that appears on the computer screen, presenting information or requesting input from the user. A dialog box is also known as a pop-up window.

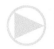
Transferring photos using a memory card reader

You can transfer photos using a memory card reader – a device you attach to a computer that can read the memory cards used by your digital camera. Memory card readers usually come in two forms: those for a single type of memory card and multi-card readers that accept several different types of cards. They have several advantages:

▶ Some memory card readers copy photos to a computer faster than using the camera itself
▶ If you transfer photos regularly, you can save time plugging and unplugging cables by leaving it connected
▶ Memory card readers avoid the additional drain on the camera batteries when transferring photos
▶ Memory cards work with lots of different computers. They don't require special software to be recognised and most work straight after they've been plugged in

To use a memory card reader:

1 Attach the memory card reader by plugging the supplied cable into the computer's USB port

② Turn off the camera and remove the memory card from it

③ Insert the memory card into the card reader. Be careful to insert it correctly, you shouldn't have to use force to get a card into a reader

④ The card reader will show up on your computer. The computer will normally recognise a card reader and a pop-up window will appear to start the download process

Transferring photos using a docking station

Some digital cameras – notably Kodak models – come with a docking station (see page 206). This is a device that your camera slots into and it then connects directly to a computer so your photos can then be downloaded. The benefit of docking stations are that they can be left connected to your computer permanently once installed, avoiding the need to fiddle with cables or remove memory cards.

(see page 206)

TIP
Docking stations can also be used to charge the camera's batteries

① Place the camera, turned off, in the docking station

② Attach one end of the supplied cable into the docking station

③ Connect the other end of the cable into the computer's USB port

④ Turn on the camera and the computer should recognise that a docking station has been attached and the software that is provided with the docking station should begin the photo download process

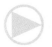

IMPORT PHOTOS WITH WINDOWS LIVE PHOTO GALLERY

The two most recent operating system on PCs are Windows Vista and Windows 7.

▶ **Window Vista** users can use Windows Photo Gallery – a photo-management tool that makes it easy to view photos as well as edit, print and manage them

▶ **Windows 7** users can use the Windows Live counterpart, Windows Live Photo Gallery. For ease of reference, Windows Live Photo Gallery is referred to throughout this book

Whether you have Windows Vista or Windows 7, you will see the AutoPlay window as used in this example.

1 Connect your camera or card reader to your computer and switch on

2 The Windows AutoPlay box opens with a list of options for getting the photos

3 Click **Import pictures and videos** to copy photos from your camera

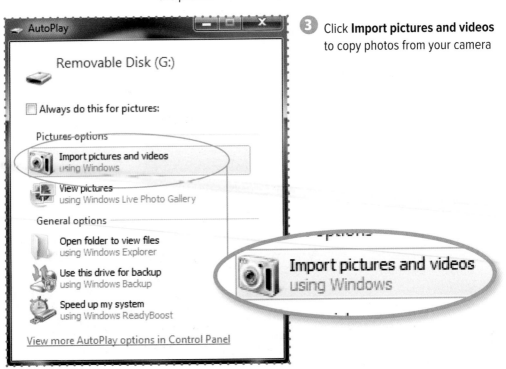

4 You can tag or name your photos – such as 'French Trip Spring 2010' – (see pages 95 and 102–3) to help you find and organise them later. If you choose to do this, write the name of the tag in the box shown and then click **Import**

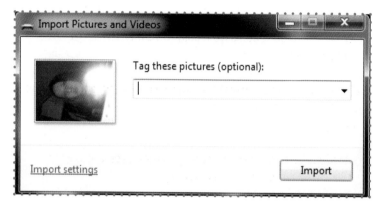

5 Click **Import Settings** to bring up the Import Settings box. Here you can specify a folder for your imported images, rotate images or, by clicking the **Erase After Importing** box, delete the photos from your memory card once you've downloaded them. This frees up space so you can take more with the digital camera

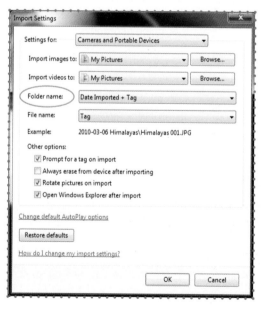

6 Your photos will appear in the named folder in the Windows Photo Gallery (see pages 108–9)

7 Turn your camera off again before unplugging the cable from both the camera and the computer

NEXT STEP ▶

Information about viewing photos in Windows Live Photo Gallery is given on pages 108–9.

managing your photos

ORGANISE PHOTOS WITH WINDOWS LIVE PHOTO GALLERY

Windows Live Photo Gallery offers several ways to help organise your photos so you can quickly find those you want.

Renaming your photos

Your digital camera stores each photo with a numeric file name so they appear on your computer with names like DSC00267.JPG and P0000255.JPG. To rename each photo to something more recognisable can be time consuming, but Windows Live Photo Gallery lets you rename an entire group of photos at once.

1 Open Windows Live Photo Gallery by clicking **Start** and then **All Programs**. Then click **Windows Live Photo Gallery**

2 To see your photos, click the arrow next to **All photos and videos**, and then click **My Pictures** in the left-hand pane

3 Hold down the **Ctrl** key, and click the photos you want to rename

4 Click **File** and then **Rename**

5 In the Information pane, type the new name for that group of photos in the name box

6 Each photo is given the new name with a different sequential number, for example: Beach Holiday (1), Beach Holiday (2), Beach Holiday (3), and so on

Tagging your photos

Tags can be applied to single or several photos at a time, and you can add tags that name people in the photo or descriptive tags such as 'Snowy Day'.

1 To apply a tag, click the photo. To select more than one photo at a time hold the **Ctrl** key while you click photos

2 From the left-hand navigation pane, click either **People tag** or **Descriptive tag**

People tags

Add people tags

That's me!

Sally

Descriptive tags

Add descriptive tags

snowy day

TIP

Another way to add tags is to drag a photo to a tag in the Tags list

3 Type a tag name and press enter

Rating your photos

You can also organise your photos by rating them on a scale of one to five. Five being your favourite photos and one those photos you never wish to show anyone.

1 To apply a rating to a photo, click the photo. To select more than one photo at a time hold the **Ctrl** key down as you click photos

2 In the Information panel on the right next to the word Rating click on the number

of stars to give the rating you wish. The more stars you give a photo, the higher the rating

Deleting your photos

To delete a photo, simply click on it (or use hold the **Ctrl** key down as you select more than one photo at a time) and click **File** then **Delete**. In the box that appears, click **Yes**.

IMPORT AND ORGANISE PHOTOS WITH ADOBE PHOTOSHOP ELEMENTS 8

It's easy to import your photos direct from your digital camera or memory card into Adobe Photoshop Elements 8 using the program's built-in Photo Downloader. You can even set the Photo Downloader to detect a memory card reader or digital camera when you attach it to the computer's USB port and then automatically download photos.

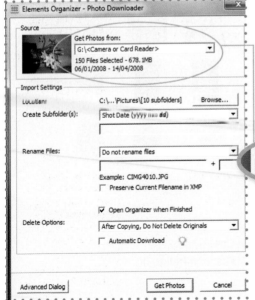

1. Connect your camera or card reader to your computer and switch on the camera

2. The Windows AutoPlay box opens with a list of options for getting the photos. Click **Organize and Edit** and then click **OK**

3. If Elements Organizer is not already open, the Photo Downloader box opens

4. If you have Elements Organizer open already, choose **File**, then click on **Get Photos And Videos** and then **From Camera Or Card Reader** to open the Photo Downloader

5. Choose from the **Get Photos From** menu to specify where to copy/import the photos from

Creating settings

You can also set the following options:

1 Location This lets you specify a folder to which images are downloaded. To change the default folder location, click **Browse**, and choose a location on your hard drive

2 Create Subfolder(s) You can create a subfolder using the naming scheme chosen from the pop-up menu. If you choose **Custom Name**, type a subfolder name in the box

3 Rename Files This will change the filenames of the photos using the naming scheme that you select from the pop-up menu, such as the shot date or a custom name plus shot date. By clicking on **Custom Name** you could also type in your own name and a starting number for assigning sequentially numbered filenames to the photos

4 Preserve Current Filename In XMP Tick this box to use the current filename as the filename is conveniently stored in the metadata of the photo

5 Delete Options Here you can choose whether to leave the photos on your camera or card, delete them before importing them, or delete the files after they're copied

Jargon buster

XMP
Short for Extensible Metadata Platform, XMP is a standard way for embedding information (metadata) in a digital file, most commonly used on photo files.

TRY THIS

To automatically download photos to Adobe Photoshop Elements 8 after a device is connected, select Automatic Download which will open when you connect your camera or memory card.

Using further options

1 For more download options, click the **Advanced Dialog** button at the bottom left to expand the window and reveal thumbnails of all the photos on the memory card (as shown below). The Advanced Dialog box offers all the options in the Standard Dialog box plus several additional ones. For example, you can view all of the media files stored or preview videos before importing them

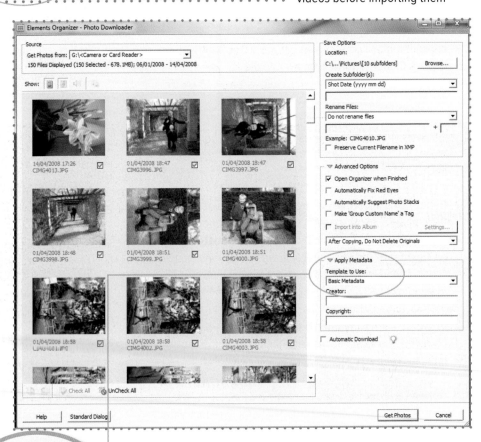

2 You can also add information in the Apply Metadata box (see Step 3), specify an album for the imported photos, and automatically fix red eye as the images are imported. The settings you specify in this box remain the same until you reset them

③ Use the **Apply Metadata** option if you intend to share images over the web or, perhaps submit photos to magazines for publication or competitions. Type your name and copyright information into the text fields, and they'll be embedded in each of the download images from your memory card

④ There may be times when you don't want to download all the images on the memory card. You will see a tick underneath each of the thumbnails. Click the checkbox at the bottom right of the thumbnail of those you *don't* want to import

Downloading

When you're happy with your settings, click **Get Photos**. Elements Organizer will open and import the photographs. The window will then show only the photos you have imported, as below. Click **OK.**

managing your photos

 # Managing Your Photos

VIEW YOUR PHOTOS

Once you have downloaded photos onto your computer you can view them in several different ways. On a Windows PC your photos are stored in the Pictures folder and you can open this folder to view the pictures stored there. To open the Pictures folder, click **Start** and then click **Pictures.**

Using Windows Live Photo Gallery

Windows Live Photo Gallery works with the Pictures folder, so that any of your photos that are in the Pictures folder will automatically appear in Photo Gallery.

1 Click **Start**, then **All Programs** and then click **Windows Live Photo Gallery**. Alternatively, right click on a file in the My Pictures folder and select **Preview** or double click on a photo to open it in Windows Live Photo Gallery

2 To see your photos, click the arrow next to **All photos and videos**, and then click **My Pictures** in the left-hand info pane

3 Your photos are grouped by date (initially) and as thumbnails, which are small versions of the full-sized photos. To see as many thumbnails as possible, click the **Maximize** button so that the Windows Live Photo Gallery window fills your computer screen

4 Change the size of thumbnails by clicking the **Zoom** button at the bottom of the screen and moving the slider up or down. Making thumbnails smaller lets you browse a large picture collection or making them larger lets you see more detail. Changing the thumbnail size doesn't affect the full-sized version of the photo

5 To view a photo at full size, double click on it. The photo will now fill the Photo Gallery viewer window

6 You can navigate through photos in this larger view mode by using the buttons at the bottom of the screen. To move to the next photo, click on the right arrow. To see the previous photo, simply click on the left arrow

7 You can rotate photos by clicking on the rotate buttons at the bottom of the screen

TRY THIS

Moving your cursor over an item without clicking will display additional information, such as the date and time the photo was taken and its file size and dimensions in pixels.

managing your photos

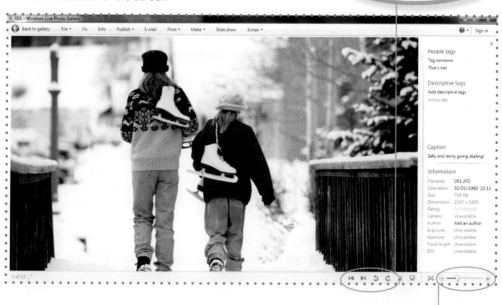

8 To zoom into your photo for closer inspection, click the **Zoom** tool on the bottom of the screen

9 To return to a thumbnail view of your photos, click **Back to Gallery** on the top left corner of the window

 # Managing Your Photos

FIND YOUR PHOTOS

As you take more and more photos and store them on your computer, finding a photo can mean trawling through hundreds of them. With your photos tagged and/or rated it is easier to find a particular photo using Windows Live Photo Gallery.

Finding photos by tag

1 Type in a word or two in the search box at the top of the Windows Live Photo Gallery

2 Any photos that have this word or words as a tag will be shown in the main viewer window

Finding photos by rating

You can search through your photo collection based on a rating.

1 On the left-hand navigation pane under the heading Ratings, click on the number of ratings you wish to search for

2 All the photos with that rating will be displayed in the main viewer window

Finding photos by date

Your digital camera labels each photo with the date they were taken. Windows Live Photo Gallery will use this to automatically organise your pictures by date, making it easy to browse photos in your collection by the year, month or day they were taken.

1 Click either a year, month or day under Date Taken in the left-hand pane of Windows Live Photo Gallery

2 All the photos taken in the time period that you've selected will appear in the main viewer window

THE BENEFITS OF BACKING UP YOUR PHOTOS

Your digital photo collection may now consist of hundreds of neatly tagged and arranged photos in folders, but should the hard drive crash or the computer be stolen or damaged, your precious photos may be lost forever. To avoid this, create a backup plan and practise it regularly. Some points to consider when backing up:

▶ **Make two copies not one** Backing up means making a second copy of your digital photos. Don't back up photos onto a CD and then delete them from the hard disk: should anything happen to that CD your photos will lost permanently

▶ **Choose a backup method** The cheapest way to back up your photos is to burn them to a CD or DVD. Always choose high-quality archival or photo-grade CDs or DVDs from well-known brands and go for non-rewritable discs as these are more stable. Discs that are not rewritable also prevent files from being accidentally deleted and damaged by viruses. If your photo collection is very large, consider a small external hard drive. These generally have very large capacities (500GB are common) and can store hundreds of thousands of photos

▶ **Make sure you back up** your photos regularly. Do it each time you've downloaded a new batch of photos from your digital camera, but it's also wise to set reminders on your computer's calendar so you get backup reminders

▶ **Store your back ups somewhere safe** and away from your computer. For the best protection, put your backup copies (whether they are on CD, DVD or an external hard drive) in a fire-proof safe. That way, even in the event of a fire or theft, your precious photographic records and memories won't be lost

▶ **Some backup websites** and online photo services, such as Kodak Gallery, Shutterfly and Snapfish, offer online storage where you upload your photos for storage on their servers. You may have to pay for this service and your photos may still be at risk should the company go out of business or have server problems

BE CAREFUL

Storage devices become obsolete over time, so keep an eye on technology developments to ensure you are always able to access your archived photos. If, for example, stores start phasing out CD drives, you'll need to pick a new backup method for your digital photos.

BURN CDS AND DVDS

If your computer includes a CD or DVD recorder, you can copy photos to a writable disc. There are lots of programs for copying files to CD or DVD but you can do this directly in Windows.

1 Click **Start**, then **All Programs** and then click **Windows Live Photo Gallery**

2 Click **All Photos and Videos** and then **My Pictures** to view your photo collection

3 Select the photos you wish to copy to a CD

4 Click **Make** and then click on **Burn a data CD** from the menu along the top of the window

5 Insert a blank CD into your disc drive

6 Enter a name for your CD

7 Click **Burn to disc**. The burner will now write the selected photos to the CD

BASIC PHOTO-EDITING

By reading and following all the steps in this chapter, you will get to grips with:

- ▶ **Removing red eye from portraits**

- ▶ **Resizing images for the web and print**

- ▶ **Cropping, straightening and brightening photos**

Basic Photo-editing

GET TO GRIPS WITH PHOTO-EDITING

The great thing about digital photography is that the creative possibilities don't end when you take your photo.

With conventional film camera, the only way to alter photos you've taken involves complex processing in a dark room. With digital photography, though, you can use photo-editing software on your computer to do simple changes such as enlarge, correct or improve your shots as well as create special effects, such as turning your photo into a sketch or watercolour.

What can I do with photo-editing software?

Photo-editing programs let you make changes to photographs stored on your computer. You can edit prints that you've scanned in, such as old black-and-white pictures, or snaps taken with your digital camera. The software comes with a range of tools for correcting and manipulating your photos (see pages 116–117). In this chapter, information is provided for using Windows Live Photo Gallery and Adobe Photoshop Elements 8.

▶ Windows Live Photo Gallery has many basic editing tools (see pages 118–122)

▶ Adobe Photoshop Elements 8 is more sophisticated than Windows Live Photo Gallery, so in addition to the editing information given in this chapter (see pages 123–40), more advanced editing skills are described in the following chapter (see pages 142–76)

How easy is a photo-editor to use?

Most photo-editing programs take practice to get to grips with, but many have automatic correction tools that do the work for you. The success of such tools can vary, however.

▶ The most powerful photo-editing programs have plenty of manual options, too, giving you the freedom to make precise adjustments

▶ Or you may choose to ignore features, such as the histogram, which graphically displays the levels of different colours and light there is in an image

TRY THIS

Adobe Photoshop Elements 8 is a powerful photo-editor with lots of features but is still easy to get to grips with for both basic and advanced editing skill.

Do I need a photo-editing program with all the features?

Many digital cameras are sold with simple photo-editing software; Windows Vista and Windows 7 also have some basic editing tools, which let you adjust exposure, colour and size, as well as remove red eye. The more sophisticated packages are jam-packed with filters and adjustable tools but it's unlikely you'll ever need or want to use the really advanced features, so you may prefer to opt for a cheaper, more basic photo-editing package.

Will my computer be powerful enough?

Some photo-editing packages – particularly those crammed with features – require relatively powerful computers. You'll need at least Windows XP for most of them, for example.

Should I go for a paid-for program or a free download?

Most paid-for programs are available as boxed packages and come on a CD. The advantage of this is that should you need to reinstall the program for whatever reason, you can just pop the CD back in and reinstall it. You're also more likely to find that you get a printed manual in the box (though sometimes it's loaded on the CD).

▶ It's often possible to find photo-editing programs cheaper online if you're prepared to shop around. Some programs are only available to download (in some cases free of charge)

▶ If you don't mind sacrificing some of latest features, you may well find an older version of a good program for a much lower price, too

▶ Free downloads require a fast internet connection. Some are cut-down versions of paid-for programs so you're unlikely to get all the editing tools that are supplied with the paid-for versions

▶ More comprehensive free-downloads are available too – designed by teams of volunteer developers. Compared to paid-for programs, you may find they are slightly harder to get to grips with

TIP
Always check your computer meets the software's minimum requirements before you buy.

 # Basic Photo-editing

COMMON PHOTO-EDITING FEATURES

If you've never used a photo-editing program before, here's the lowdown on how it can help transform your photographs.

Manual and automatic tools

Good photo-editing programs come with both automatic and manual editing features.

- ▶ Automatic correction functions (as shown left) are very useful, but the results can be mixed, as the program has to make assumptions about how much colour and light there should be in the photo, and it doesn't always guess correctly
- ▶ Most photo-editors have an 'undo' function, which lets you return your photo to its original state if you're not satisfied with the results of an adjustment
- ▶ Manual tools give you the freedom to make more precise adjustments. The more sophisticated photo-editing packages are jam-packed with a huge array of filters and tools
- ▶ While you should be able to get to grips with basic editing features quite quickly, expect a steep learning curve as you start to use more advanced features

Red eye removal

We've all taken flash photos indoors only to find that all the people looking at the camera have developed demonic-looking red eyes. Red eye is caused when the light from a camera flash reflects off the blood-red tissue at the back of the eye.

- ▶ The trick to avoid this is to use the flash mounted off-camera, but that's not always possible, especially if you're using a compact camera
- ▶ Thankfully, most photo-editing programs offer a red eye removal tool, which works by cleverly replacing the red pupil with a more natural black one
- ▶ Generally, you select the size of the area you want to correct and can even add a glint to the eye to make it look more realistic (see pages 120 and 136)

Crop tool

The crop tool is a common feature of photo-editing software. It lets you select an area of an image and get rid of everything else in the picture. Cropping is a quick and easy way to remove distracting elements, focus on one part of the scene or change a photo's proportions (see pages 119 and 126–7).

Colour and brightness

Many photo-editing programs let you adjust the lighting and colours. Advanced packages come with features that let you get more creative with your snaps (see pages 118 and 138–9).

Scratch removal tools

Some programs include scratch removal tools that can smooth over tears and creases you may find in an old photo you have scanned into your computer. These are fine for smaller scratches, but more significant damage can be treated with a clone stamp tool (see below).

Clone stamp tool

For those photos that would be perfect if it weren't for the complete stranger who walked into shot at the last minute, the clone stamp tool is an ideal solution. You can select an area of the background, for instance, and use it as a brush to 'paint' over the top of the unwanted bystander (see pages 144–5).

Resizing tools

You can use photo-editing software to resize digital photos, making them larger or smaller. This is useful when you need to reduce the size of a high-resolution photo taken by your camera to use it on the internet or to send it to friends and family via email (see pages 124–5).

Special effects

Many photo-editors offer a wide range of special effects that can create spectacular or downright bizarre results. Photos can be skewed and distorted in various ways or transformed into watercolour paintings or Warhol-like masterpieces (see pages 148–9).

Output options

Most photo-editors offer a range of output options for your photos Options include print, pdf and internet use with photos optimised for each (see pages 178–202).

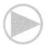 # Basic Photo-editing

TRY THIS
Each of the editing tools described on pages 118–122 are also described later in this chapter for the Adobe Photoshop Elements 8 program.

EDIT USING WINDOWS LIVE PHOTO GALLERY

With just a few clicks in Windows Live Photo Gallery, you can remove red eye, fix exposure problems, and correct colour, or crop photos for more impact.

Editing automatically

1 Click **Start**, then **All Programs**, and then click **Windows Live Photo Gallery**

2 Click **All Photos and Videos**, and then click **My Pictures** in the left-hand info pane

3 Select the photo you wish to adjust and click **Fix** on the menu at the top of the window. A side panel will appear to the right of the photo with several fix options available

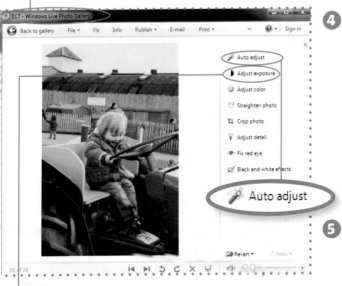

4 There is one automatic option available: **Auto adjust**. Click on this if you want Windows Live Photo Gallery to automatically optimise the photo's brightness, contrast and colour. Remember you can always click undo should you not like the result of this fix

5 Click **Back to Gallery** to automatically save the changes to your photo

Manually changing the brightness and contrast

1 Click **Adjust exposure** to manually adjust the brightness and contrast of a photo

2 Use the **Brightness slider** to change the brightness: moving it to the left will make the photo darker and moving it to the right will make it brighter

3 Similarly, moving the **Contrast slider** to the left will decrease the contrast and to the right will increase it. Your photo will show these changes as you move the sliders. Play with the settings until you're happy with the results

4 Click **Back to Gallery** to automatically save the changes to your photo

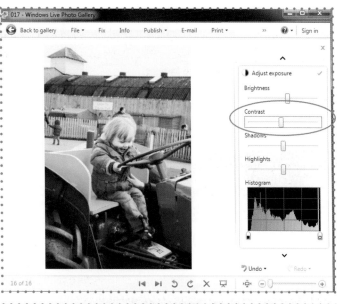

Manually adjusting the colour

1 Click **Adjust Color**

2 Use the sliders to change the photo's **Color Temperature**, **Tint** and **Saturation**

3 When you are happy with the results, click **Back to Gallery** to automatically save the changes to your photo

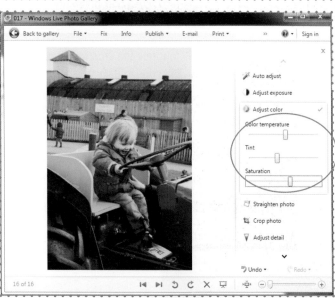

Cropping your photo

1 Click **Crop photo**

2 If you want to change the photo's proportions, click a specific print proportion in the list, such as 4 x 6. Alternatively, click **Custom**, which lets you set any picture proportion, or **Original**, which retains the proportion of the original picture

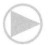 # Basic Photo-editing

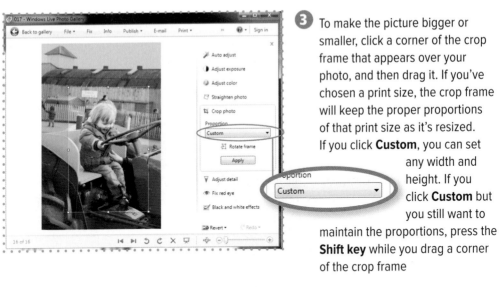

3 To make the picture bigger or smaller, click a corner of the crop frame that appears over your photo, and then drag it. If you've chosen a print size, the crop frame will keep the proper proportions of that print size as it's resized. If you click **Custom**, you can set any width and height. If you click **Custom** but you still want to maintain the proportions, press the **Shift key** while you drag a corner of the crop frame

4 To select a part of the photo to focus on, simply drag the crop frame around over the photo

5 To rotate the crop frame so the picture is cropped vertically rather than horizontally or vice versa, click **Rotate Frame**

6 When you are happy with your adjustments, click **Apply**

Removing red eye

1 Click **Fix red eye**

2 Click the upper-left corner of the first eye that you want to correct, and then drag the mouse pointer to the lower-right corner of the eye to create a selection around the eye

3 Repeat this for the second eye

4 Click **Back to Gallery** to automatically save the changes to your photo

Straightening a photo

If you discover that a photo you've taken is at an angle, you can use Windows Live Photo Gallery's Straighten Photo tool in order to adjust the horizon.

1 In Windows Live Photo Gallery, select a photo you wish to adjust

2 Click **Fix** from the top toolbar

3 Windows Live Photo Gallery opens your photo and shows a list of photo-fixing tools in a pane on the right of the screen

4 Click **Straighten photo**

5 Windows Live Photo Gallery will automatically adjust your photo, and places a grid over the results, as shown right

6 If necessary, click the **Undo** button to undo changes. You can press **Ctrl+Shift+Z** to undo all changes, or **Ctrl+R** to revert to the original photo

7 When you've finished making adjustments, click **Back to gallery**

Basic Photo-editing

Making a photo look sharper

Many digital photos have a soft, slightly fuzzy look but you can use Windows Live Photo Gallery's Adjust detail tool to correct this. By applying this tool, Photo Gallery finds and enhances edges (where pixels of different colours butt up against each other) to produce an image that appears more in focus.

1 In Windows Live Photo Gallery, select a photo you wish to adjust

2 Click **Fix** from the top toolbar

3 Windows Live Photo Gallery opens your photo and shows the list of photo-fixing tools along the right side

4 Click **Adjust detail**

5 Zoom into the photo to see an area in more detail. This will make it easier to see the changes you're making

6 Under the Adjust detail tab is a slider labelled Sharpen. Move the slider to the right to increase Sharpening. Be careful not to oversharpen as the image quality will deteriorate

7 The Reduce Noise slider does the opposite of what the Sharpening tool does. It finds pixels that are significantly different from neighbouring ones and smoothes them. To reduce noise, click the **Analyze** button. Windows Live Photo Gallery will automatically reduce noise in the photo

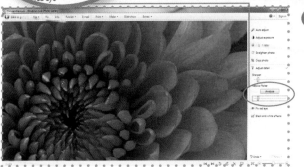

8 You can use the slider to lessen the amount of noise reduction by moving it to the left or increase the amount by moving it to the right. Reducing noise will make the picture look softer. To save your changes, click **Back to gallery**

EDIT USING ADOBE PHOTOSHOP ELEMENTS 8

With this program there are three ways to edit your photographs:

▶ The Full Edit window has powerful tools to correct colour problems, create special effects and enhance photos

▶ Edit Quick offers simple tools for correcting colour and lighting, and fixing common problems like red eye

▶ Guided Edit has instructions and simple commands that walk you through a few basic photo-editing tasks, making it a good starting place for those new to Adobe Photoshop Elements 8

Adobe Photoshop Elements 8 is actually two programs in one: a photo-editor and an organiser. You can view, print and do basic edits in the organiser, but most photo-editing tasks need to be done in the editor.

Opening pictures in Adobe Photoshop Elements 8

1 Click **Start** and then **All Programs.** Click **Adobe Photoshop Elements 8**. On the Welcome screen click **Edit**

2 Click **File** and then **Open** and browse your computer's hard disk to locate the photo you wish to open. Select a photo and click **Open**. The photo will now appear in the Editor window

3 Click and drag on the bottom-right corner of the window to resize the window but without resizing the photo on screen

4 To view the photo at a different size, click **View** from the top menu bar and select either **Zoom In**, **Zoom Out**, **Fit on Screen** and **Actual Pixels**. Keyboard shortcuts are listed next to each settings and learning these will help speed your editing as you then don't need to move the cursor around the screen so much, using key combinations instead

5 To close a photo, click **File** and then **Close**. If you have made any changes to the photo, a pop-up window will ask you if you wish to save the photo before closing it

RESIZE PHOTOS

With digital photography, it is possible to both shrink and enlarge images so you can send smaller files by email, for example, or print out a larger size photo than normal. All photo-editing packages include the ability to shrink or reduce images, and some include special tools to increase the size of a photo without it blurring and losing detail. Here's how to do it using Adobe Photoshop Elements 8.

Shrinking photos for email

If your digital camera is taking photos using high quality or fine settings, the resulting photo files can be too big to sensibly share with friends and family using email, but it can be quickly done.

1 Open a photo you wish to resize

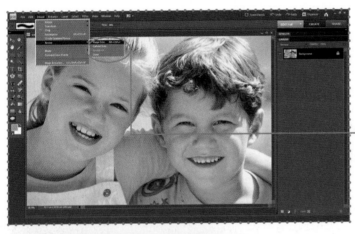

2 Click **Image**, followed by **Resize** and then **Image Size** from the top menu

3 In the Image Size box make sure that **Scale Styles**, **Constrain Proportions** and **Resample Image** are all ticked

4 Type the width of the image you want into the top field labelled **Width**. This is usually a measurement in pixels – in this case, a width of 600 pixels is fine for most photos you want to email. The **Height** value will automatically change as you type. Press **OK**

5 Choose **File** and then **Save For Web**. On the far-right pane, choose **JPEG** from the pop-up menu, and choose **High** from the pop-up menu underneath. Use the **Quality** slider to set the quality to **60**. Click **OK**. When prompted, choose where you want to save your now much-smaller, resized photo

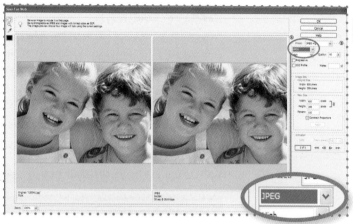

Enlarging photos

While it's possible to make photos bigger in photo-editing software, it is best avoided as the computer software has to 'guess' at the missing detail that a photo needs to increase its size. However, there are some steps you can take to get a better result.

1 With your photo open, choose **Image**, then **Resize** and then **Image Size** from the menu. In the **Image Size** box, make sure that **Scale Styles**, **Constrain Proportions** and **Resample Image** are all ticked

2 Ensure that the pop-up menu next to Resample Image has **Bicubic** selected

3 Increase the width of the image, changing the **Width** setting in the pop-up menu to **percent**. In the **Width** field, enter a value up to around 200%. Any larger than 200% will significantly blur the image

4 Choose **File** and then **Save**. If you wish to keep the original photo, click **File** and then **Save As** and give the different sized version a different name

TRY THIS

Do you want to print a standard photo? Use one of the set photo aspect ratios such as 10 x 12cm (4 x 5in), but leave the Resolution box blank. When the photo is cropped, the correct resolution for the area is determined for you.

CROP PICTURES

One of the fastest and simplest ways to improve a digital photo is to crop it. Cropping is the process of removing a part of the photo so the focus is where you want it to be. For example, you may wish to remove an ugly object from the background of a shot or crop out empty space around your subject. Here's how to do it in Adobe Photoshop Elements 8.

1 Open a photo you wish to crop

2 On the toolbar click the **Crop** tool

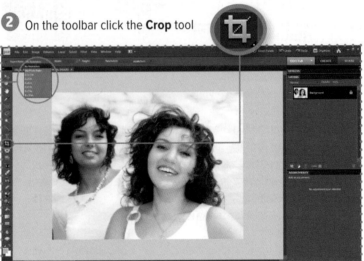

3 In the options bar, click the crop options you want. Leave the default aspect ratio (see Try This, above left) set to **No Restrictions** as this lets you crop the photo to any shape or size you want. (You can, however, select a different aspect ratio from the drop-down list, or enter a custom width, height, or resolution for your crop)

TRY THIS

If you are using Windows Live Photo Gallery, see page 119 for cropping pictures.

4 Place your cursor where you want the top-left corner of the crop to start and click and hold down your mouse button. Then drag your mouse to where you want the crop to end and release the button. The area of the cropped photo will be highlighted and the area outside will be dimmed

TRY THIS

You can also use the crop to select just one person from a group shot or crop a photo to a specific size.

⑤ If you're not happy, you can adjust the crop:
▶ Either by clicking within the cropped area and dragging the rectangle around your photo, you can position the crop area exactly where you want it to be
▶ Or by clicking and dragging on any of the handles (the small squares at each corner and halfway along each edge of the crop box) to change the size and shape of the cropped area

⑥ When you're happy with the crop area, click **OK** or press **Enter** to complete the crop. When you're happy with the crop area, click **OK** or press **Enter** to complete the crop

⑦ Click **File** and then **Save** to save the new cropped image. If you wish to keep the original photo, click **File** and then **Save As** and give the cropped version a different name

Jargon buster

Aspect ratio
The aspect ratio refers to the relationship between the width and height of a digital photograph. For example, if a photo has an aspect ratio 2:1, it means that the width is twice as large as the height.

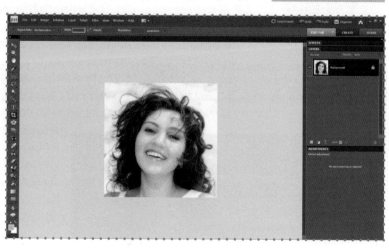

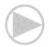

Basic Photo-editing

TRY THIS

If you are using
Windows Live Photo
Gallery, see page 121 for
straightening a photo.

STRAIGHTEN PHOTOS

One of the benefits of using a digital camera is that you can snap away
and capture shots you might otherwise miss. Yet this spontaneous
approach to photo taking can mean you don't take the time to set up
your shots or use a tripod and the end result can be a crooked photo.
Using Adobe Photoshop Elements 8, it's easy to straighten images.

1 Open a photo you wish to straighten

NEXT STEP

The other option on
the straighten toolbar
is Rotate All Layers.
Working with layers is
described in details on
pages 150–1. If you are
working with layers and
wish to straighten them
all together, ensure the
option is ticked.

2 Click the **Straighten** tool

3 On the option bar, click on **Canvas Options** and choose an option
from the pull-down menu:

▶ **Grow or Shrink Canvas to Fit** resizes the background to fit the
rotated image. The straightened image will contain areas of blank
background, but no pixels from the photo are removed

▶ **Crop to Remove Background** crops the image to remove any
blank background area that becomes visible after straightening

▶ **Crop to Original Size** keeps
the canvas the same size as the
original image. The straightened
image will include areas of blank
background and some pixels will
be removed

Using Grow or Shrink Canvas to Fit

1 Set the Canvas Option to **Grow or Shrink Canvas to Fit**. Locate a line within the photo that will serve as a straightening guide. In this case, it's the horizon

2 Using the **Straighten** tool, click and hold down the mouse button to drag along this line right to the edge of the photo. Release the mouse button and a dotted line will appear

TRY THIS

Adobe Photoshop Elements 8 has straightening and cropping tools that are designed to work best with photos that have been scanned crookedly on a flatbed scanner. To use, click **Image**, then **Rotate** and then **Straighten And Crop** Image.

basic photo-editing

3 Adobe Photoshop Elements 8 will now rotate your photo to make that line horizontal. In doing this, empty wedges of canvas background can be seen (see below right)

4 To remove these, use the **Crop** tool (see overleaf). This approach offers greater flexibility in choosing the final look and aspect ratio of your photo than using Photoshop Element's automated Crop To Remove Background option

Using the crop tool

1 Click the **Crop** tool from the toolbox

2 Click and drag inside the photo to draw a rectangular selection, making it as large as possible without including any of the empty background wedges

3 Click the green **Apply checkmark** that appears in the tab at the bottom-right corner of the crop selection box or just press **Enter**

4 Everything outside the crop selection box is removed and the result is a photo that appears straight, as seen below

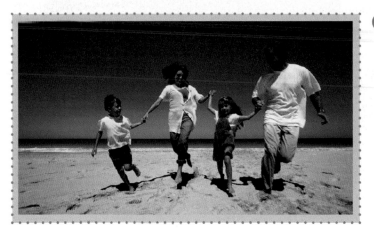

5 Click **File** and then **Save** to save your photo. If you wish to keep the original photo, click **File** and then **Save As** and give the straightened version a different name

CHANGE COLOUR

If the colours in your digital photo look less than realistic, it may be the result of a colour cast. This is simply an unattractive colour shift that sees an overall colour tone, usually yellow, applied to the photo. It often happen when using a built-in flash, or when a photo is taken indoors without a flash. Colour casts can be toned down or removed using photo-editing software such as Adobe Photoshop Elements 8.

TRY THIS

If you are using Windows Live Photo Gallery, see page 119 for adjusting colour.

1 Open a photo you wish to work on

2 On the top menu bar click **Enhance** and from the drop-down menu, click **Adjust Color** followed by **Remove Color Cast**

3 Click an area in your photo that should be white, black or grey. The colours in your photo are then adjusted based on the colour you selected

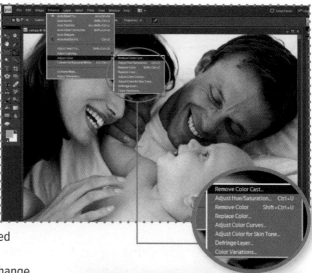

4 Click **OK** to accept the colour change

5 Click **File** and then **Save** to save your photo. If you wish to keep the original photo, click **File** and then **Save As** and give the different coloured version a different name

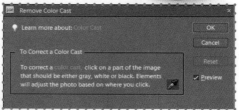

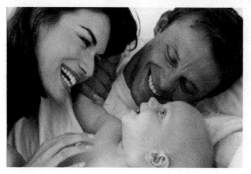

Before

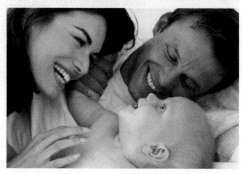

After

REDUCE NOISE

When you're taking photos indoors or under low light without a flash, you'll almost certainly need a high ISO setting (see page 23) to prevent blur from camera shake. However, this increase in camera sensor sensitivity, either automatically or by using manual selection, will inevitably result in raised noise levels (see page 23), leading to off-putting coloured blotches and speckles on your photos. To overcome this problem using Adobe Photoshop Elements 8:

1 Open a photo that has high levels of digital noise or, to check for noise in images, double click the **magnifying glass icon** in the Editor to view at 100%

2 Select **Filter**, then **Noise** and then **Reduce Noise**. This brings up the **Reduce Noise** box complete with three sliders to adjust, each of which are described in Steps 5 and 6:
 ► Strength
 ► Preserve Details
 ► Reduce Color Noise
 as well as a preview pane at 100%

3 Click and drag the preview image to reposition the image for a clearer view of the blotches and speckles. By default, the filter applies some moderate noise reduction, so making additional adjustments with the sliders to the left or right of the defaults will, respectively, reduce or increase the effect

4 To view the change before and after making any adjustments, click and hold the preview image

5 Should the colour blotches be quite noticeable after the initial adjustment, drag the **Reduce Color Noise** slider up to around the 70 to 80% level. Click and hold the preview pane in order to gauge the effect

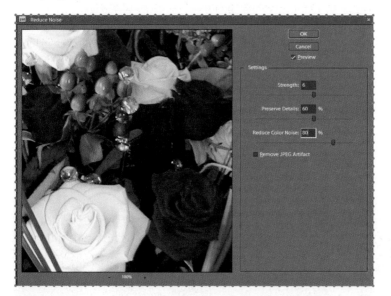

TRY THIS

If the preview image takes some time to refresh, uncheck the **Preview** checkbox, then select it again straightaway

6 If the image still look grainy, drag the **Strength** slider further to the right. This will soften the photo quite considerably, but if you pull the **Preserve Details** slider to the right, in small steps, some detail will return. Take care not to overdo it though, as noise will reappear. Unless you can see artifacts such as blocks or tiles appearing in your image (at 100%), you can leave the Remove Jpeg Artifact box unchecked

7 Click **OK** to apply the changes

8 To save your changes, click **File** and then **Save.** If you wish to keep the original photo, click **File** and then **Save As** and give the sharpened version a different name

Jargon buster

Artifact
A defect or flaw in a digital image.

TRY THIS

If you are using
Windows Live Photo
Gallery, see page 122
for sharpening a photo.

SHARPEN PHOTOS

With digital technology the photos your camera captures can appear
slightly soft. You may not notice this at first, but if you sharpen a photo
in a photo-editor, the effect is obvious. Sharpening boosts the details
by increasing the contrast of pixels next to one another.

Adobe Photoshop Elements 8 has an auto-sharpen option. However,
you've no control over the settings of this process and you may not
be happy with the results, so a better way of sharpening a photo is to
use the Unsharp Mask filter. Despite its seemingly contradictory name,
this filter reproduces a traditional film technique used to correct the
softness often visible in digital photos.

1 Open a photo you wish to sharpen. Click **Enhance** and then
Unsharp Mask

2 On the Unsharp Mask window that appears (see opposite, top),
make sure the **Preview** option is checked and set it initially at
100%. The preview window will show how the level of sharpening
you apply will affect your photo

TRY THIS

If you need to reduce
image noise in your
photo, do this before
sharpening as the latter
can intensify the noise
(see pages 132–3).

3 You can click and drag the preview to show a particular area of
your photo. You can zoom into the preview by setting a higher
degree of magnification (from 1 to 500%)

Setting the sharpening parameters

Under the preview window are three sliders. The sharpening effect on your photo will depend on how you set them.

① Use the Amount slider to increase the contrast of image pixels. For high-resolution printed images, an amount between 150% and 200% is usually best

② Use the Radius slider to determine how many pixels are influenced by the amount of sharpening. A radius between 1 and 2 is usually best. A lower value sharpens only the edge pixels, whereas a higher value sharpens a wider band of pixels

③ Use the default Threshold value (0) to sharpen all pixels in the image. However, if a photo has a lot of digital noise (distortion), avoid zero as the final photo may look grainy. In this case, try experimenting with values between 2 and 20

④ Experiment with the values to suit your photo and when you have made your adjustments, click **OK**

⑤ To save your changes, click **File** and then **Save**. If you wish to keep the original photo, click **File** and then **Save As** and give the sharpened version a different name

TRY THIS

If you want to selectively sharpen parts of your photo, click **Enhance Sharpen** and then select the various options in the option bar, including sharpening strength. Now drag the sharpening tool over the area you wish to change.

Before

After

basic photo-editing

135

TRY THIS

If you are using Windows Live Photo Gallery, see page 120 for removing red eye.

REMOVE RED EYE

You've just taken a perfect shot of a family member but the photo seems ruined by the subject's demonic-looking red eyes. This is caused by the illumination of the subject's retina by the camera's flash and it often happens when taking pictures in a darkened room because the subject's iris is wide open. You can remove red eye using Adobe Photoshop Elements 8 either automatically or manually.

Removing red eye automatically

When importing or downloading images using the Adobe Photo Downloader, Adobe Photoshop Elements 8 should search for and remove red eye automatically by default. If it doesn't:

1 Check the setting by clicking **Edit** and then **Preferences**

2 Click **Camera** or **Card Reader** from the left-hand menu, and select **Automatically Fix Red Eyes**

Removing red eye manually

1 Open a photo that is in need of red eye removal

2 From the Full Edit Mode, select the **Zoom** tool and left click and drag to make a selection around the eyes. Zoom in to get a close-up view of the eyes

3 Click the **Red Eye Removal** tool from the toolbox – it looks like an eye with crosshairs

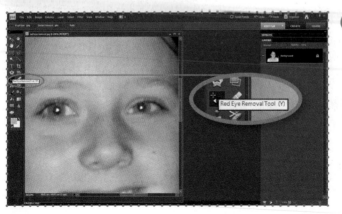

4 For a quick fix, click and drag the **Red Eye Removal** tool over the eye to make a selection or click a red area of an eye. Then press **Auto** from the options bar above the photo window. The red area is automatically located and replaced with a neutral grey

5 You'll need to apply this technique to each eye in turn, but it's a quick and effective option if you have lots of images to correct

6 For more control over how the pupil looks, you can set the **Pupil Size** from the options bar. Click on the downward-facing arrow next to the percentage figure

7 You can also adjust the darkness of the replacement colour, as the result is often a light-looking grey. From the **Darken Amount** option drag the slider to the right to change from grey to black

8 Then simply click a red area of an eye or draw a selection over the eye area as before and the red is removed. Repeat for the other eye if necessary

9 To save your changes, click **File** and then **Save**. If you wish to keep the original photo, click **File** and then **Save As** and give the red-eye-free version a different name

 # Basic Photo-editing

TRY THIS

If you are using Windows Live Photo Gallery, see page 118 for brightening colours.

BRIGHTEN YOUR PHOTOS

Sometimes a photo that you've taken turns out to be too dark. But a too dark picture can be brightened up using photo-editing software such as Adobe Photoshop Elements 8.

Brightening a photo using Brightness and Contrast

1 Open a photo that you would like to work on

2 On the top menu bar click **Enhance** and from the drop-down menu, click **Adjust Lighting** and **Brightness/ Contrast**

3 The Brightness/Contrast box will pop up. This has two sliders with arrows that you can scroll to the right or left to add or subtract brightness and contrast. Adjust the **Brightness** slider first. Try increasing brightness in increments of 10 to start

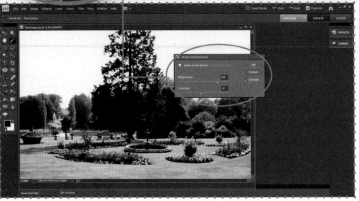

4 As you increase brightness, you may also need to increase the contrast so your image is not looking washed out. Adjust the **Contrast** slider until you are happy with the result. By ticking and unticking the **Preview** box you can see the photo before and after your changes

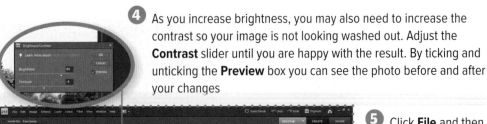

5 Click **File** and then **Save** to save your photo. If you wish to keep the original photo, click **File** and then **Save As** and give the brightened version a different name

Brightening a photo using Shadow and Highlights

On some occasions, you may wish to adjust only certain areas of a photo to bring out more details, say from an area in shadow without the lighter area of your photo becoming too washed out. In this example, the family in the foreground are in deep shadow.

1 Open a photo that you wish to work on

TRY THIS

To reset the photo to how it looked when you opened the box, hold down the **Alt** key and click the **Reset** button.

2 On the top menu bar click **Enhance** and from the drop-down menu, click **Adjust Lighting** and **Shadow/Highlights**

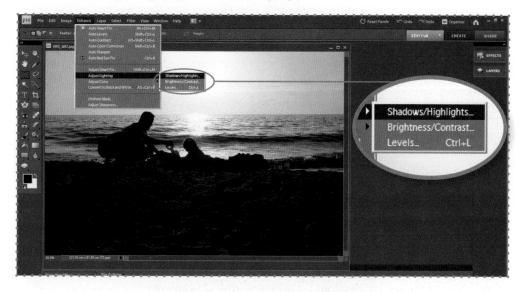

3 The Shadows/Highlights box will pop up. This has three sliders with buttons that you can scroll to the right or left to affect the shadows and highlights on the photograph

4 Scroll to the left on Lighten Shadows to brighten the dark areas of your photo and reveals more of the shadow detail

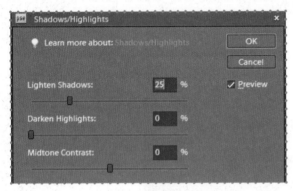

5 Move the slider to the right on Darken Highlights to darken the light areas of your photo and reveal more detail in the highlights

6 Use Midtone Contrast to add to or reduce the contrast of the middle tones. You can use this slider if the image contrast doesn't look right after you've adjusted shadows and highlights

7 Experiment with these sliders until you're happy with the result. By ticking and unticking the **Preview** box you can see the photo before and after your changes

8 Click **File** and then **Save** to save your photo. If you wish to keep the original photo, click **File** and then **Save As** and give the brightened version a different name

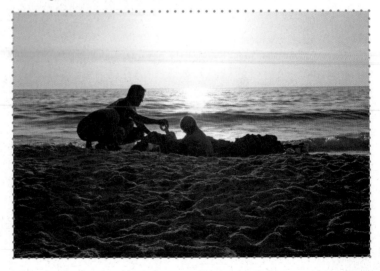

MORE ADVANCED EDITING

By reading and following all the steps in this chapter, you will get to grips with:

- ▶ **How to fix and repair photos**

- ▶ **How to add special effects to enhance photos**

- ▶ **Handling and changing colours in photos**

FIX BLEMISHES AND SPOTS

It's rare to take a perfect photo and when you view your photo you may see one or more imperfections. Flaws can range from major ones such as unwanted telegraph poles spoiling a countryside scene to portraits of family members spoilt by skin blemishes. An advantage of digital photography is that you can quickly fix minor flaws in your photo by retouching.

Adobe Photoshop Elements 8 is one the most affordable and popular photo-editing packages. Other photo-editing packages will offer similar features to those described in this chapter.

Using the Spot Healing Brush

This is best for removing smaller defects such as spots or wrinkles. You sample part of a photograph, then blend that sample with another part of the photograph. Here's how:

1 Open a photo you wish to transform

2 Click on the **Zoom** tool on the toolbar, or on the top menu click **View** and then **Zoom in**. Zoom in on the area of the photo you wish to retouch

3 Click the **Spot Healing Brush** tool. It looks like a plaster, with a dotted area in the bottom left corner of the icon

4 Choose a brush size. A brush that is slightly larger than the area you want to fix works best so that you can cover the entire area with one click

5 Choose a **Type** option in the options bar. There are two choices:
▶ **Proximity Match** is normally set as the default and works best for most skin retouching situations
▶ **Create Texture** brush type, which is more suited to areas that have a texture

6 Place the brush (the black circle) directly over the blemish. The brush appears as a circle or shape

7 Click and you'll see the spot disappear. The tool fills in the damaged area of the screen based on nearby sections of the image

8 You may see a faint white smear on the area where the blemish previously was. If so, click the brush on the same area again

9 Click **File** and then **Save** to save your retouched photo

BE CAREFUL

Using the clone stamp tool successfully takes some practice. Press **Ctrl+Shift+Z** to undo any changes you make, or consider working on a copy of the background layer (see pages 150–1).

TRY THIS

When using the clone stamp tool, the area you are sampling doesn't have to be from the photograph on which you're working. You could copy an area from another photograph you have open in Adobe Photoshop Elements 8.

Finding the Clone Stamp tool

If you need to fix larger areas of your digital photo then the Clone Stamp is the tool to use. This allows you to copy one area of an image onto another area. You can use it to remove imperfections in your photo, paint over distracting objects or even duplicate objects.

1 Open a photo you wish to transform

2 If necessary, zoom into the area you wish to retouch as this will allow for more accuracy. In this beach scene example, a tree is going to removed from the cliff top

3 From the toolbar on the left, click the **Clone Stamp** tool

Using the Clone Stamp options bar

The Clone Stamp options bar appears at the top of your screen under the main menu. The default settings are fine to use in most cases although you may want to change your brush size for more accurate retouching. However, in the option bar you can set various items.

1 To change the brush shape, click the arrow next to the brush sample and choose a brush category from the pop-up menu. Then select a brush thumbnail

2 Select a brush size that's smaller than the area to be retouched

3 Click on mode to change how the sampled pixels blend with existing pixels. Normal mode lays new pixels over the original pixels

4 A low opacity will let the image under a paint stroke show through. To replace the original image with the copied selection leave the opacity at 100%

5 When the Aligned box is checked you can move the sampled area with the cursor as you begin to paint. This is useful when you want to get rid of unwanted areas

6 Sample All Layers lets you copy from all visible layers if you're working with layers (see pages 150–1)

Clone Stamping in action

1 Place the brush (the black circle) on the photo where you want to sample. In the example here, a sample of the sky has been used to remove the tree

2 Hold down the **Alt** key (the cursor will change into a bullseye) and click. The Clone Stamp tool will duplicate the pixels at this sample point in your photo as you paint

3 Click the **Clone Stamp** tool brush on the area of the photograph that you want to retouch and paint out the unwanted area. Your sample area will be marked with a cross. The pixels from the sampled area will appear on top of your original photo

4 When you're happy with the result, click **File** and then **Save** to save your photo. If you want to keep the original photo, click **File** and **Save As** and give the retouched version of your photo a new name

More Advanced Editing

CREATE BLACK AND WHITE PHOTOS

Converting a colour photo to black and white can make a dramatic effect. The simplicity of black and white helps create atmosphere, highlight detail and adds a look of classic elegance to your photos. Regardless of the subject, this technique produces impressive results.

Most compact digital cameras can take black and white photos, with excellent results. But, ultimately, this will limit your options, as you can't then convert to colour if you change your mind at a later date.

This image of a sleeping mother and child has been chosen because of its strong composition, but converting to black and white using Adobe Photoshop Elements 8 gives it a classic elegance. You may want to choose a highly coloured image while you're experimenting with the steps explained here. It makes any slight changes you make on screen more visible and easier to interpret.

1 Open a photo you wish to transform

2 From the top menu click **Enhance,** then click on **Convert to Black and White**

3 This will bring up the Convert to Black and White box. As well as providing crucial Before and After views, the Convert to Black and White window offers six presets or styles:

▶ Infrared Effect
▶ Newspaper
▶ Portraits
▶ Scenic Landscape
▶ Urban/Snapshots
▶ Vivid Landscapes

Clicking on one of these automatically adjusts the intensity of the red, green and blue (RGB) channels, to give a certain look to the new black and white photo. In this example, Portraits has been chosen

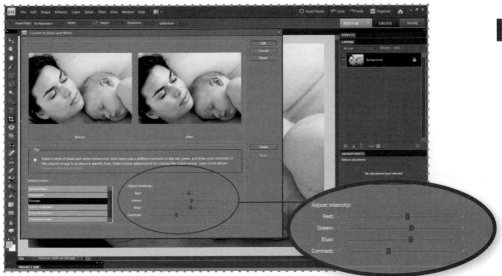

4 You can also experiment with the sliders to change or boost the black and white effect. In this example, the contrast has been boosted slightly by dragging the slider to the right

5 When finished with your selection, click **OK** to transform your photo into black and white

6 Click **File** and then **Save** to save your photo. If you want to keep the original photo, click **File** and **Save As** and give the black and white version of your photo a new name

HAVE FUN WITH ARTISTIC EFFECTS

Many photo-editing packages offer a range of effects or filters that can be applied to your photo. These can be used to transform your photo into a piece of artwork – anything from a watercolour, cartoon, line drawing to a neon or surreal image. In Adobe Photoshop Elements 8 these effects are found under the Filter menu. Here's how to use them.

1 Open a photo you wish to transform

2 With the photo open in the main window, click **Filter** then **Artistic** and from the drop-down menu choose an effect you'd like to apply to your photo. In this example **Colored Pencil** has been chosen

3 Your photo will be previewed in the Artistic filter menu window with the **Colored Pencil** filter applied. Click on the image sizing box at the bottom left of the window (here it's set at 50%) and click on **Fit in View** so you can see all of the image

4 Switch between Artistic filters on the right-hand side of the window by clicking on the name of the current filter (in this instance **Colored Pencil**). Choose other effects from the drop-down menu

5 Beneath this drop-down menu are a number of sliders, which vary depending on the type of artistic filter you're applying. In this case, there are three: Pencil Width, Stroke Pressure and Paper Brightness. Experiment with the sliders until you're happy with the result

6 Click **OK** to apply the effect to your photo and you will automatically be taken back to the Editor window

7 Save the effect by clicking **File** then **Save**. To keep the original photo, click **File** and then **Save As** and give the artistic version of your photo a new name

149

 # More Advanced Editing

TRY THIS

Using multiple layers will increase the file size of your image significantly. You can reduce the file size by merging layers that you've finished editing.

TRY THIS

To quickly open a new layer you can otherwise click on the **New Layer** button at the bottom of the Layers panel.

WORK WITH LAYERS

A powerful feature of many photo-editing packages, layers are the digital equivalent to laying sheets of tracing paper or transparent plastic over the top of a photo. They can be created and deleted by you (see below and opposite) and can be used to add other images, text or special effects to a photo, safe in the knowledge that your original photograph is protected. You can work on each layer independently to create the effect you want and each layer remains independent until you merge (flatten) the layers (see opposite).

Layers are organised in the Layers panel. The bottom-most layer is your original photograph and is called the Background layer. It is always locked (protected) so your original photo is safeguarded.

Your options when using layers

Once you have mastered the principle of using layers in Adobe Photoshop Elements 8, as explained on these two pages, you can go on to create all sorts of different effects. For example, you can:

▶ Add text to a photo (see pages 152–3)
▶ Create blur effects (see pages 154–7)
▶ Apply lighting effects (see pages 158–61)
▶ Change colours (see pages 162–5)
▶ Enhance a panoramic photo after it's been stitched together (see pages 166–9)
▶ Merge part of one picture with another (see pages 170–3)

Creating a layer

1 Open a photo you wish to add layers to

2 Click **Window** and then **Layer** to open the Layer panel

3 To create a layer with default name and settings, click on **New** and then **Layer**. The new layer uses Normal mode with 100% opacity, and is named according to its creation order Layer 1, Layer 2 and so on

4 To rename the new layer, double click it and type a new name into the highlighted box

5 If you want to create a layer and specify a name and options, choose **Layer**, then **New** and then **Layer**, or choose **New Layer** from the Layers panel menu. Specify a name and other options, and then click **OK**

6 The new layer is automatically selected and appears in the panel above the layer that was last selected

Deleting a layer

1 Drag the layer to the **Delete Layer** icon at the foot of the Layers panel or click the **Delete Layer** icon at the bottom of the Layers panel, and click **Yes** in the delete confirmation box

Selecting a layer

1 In the Layers panel, select a layer's thumbnail or name

2 To select more than one layer, hold down **Ctrl** and click each layer

Showing/hiding a layer
In the leftmost column of the Layers panel is an eye icon next to each layer. This means that the layer is visible.

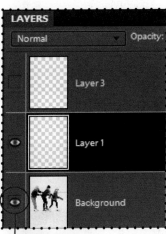

1 To hide a layer, click the **eye** icon next to the layer name

2 To show a layer, click in the same place next to the layer name and the eye icon reappears

3 To show just one layer, press alt and click the **eye** icon for that layer. Repeat alt click in the eye column to show all the layers

Merging layers
Once you are happy with the additional layers, merge them with the background. This is also known as flattening.

1 Right click on **Layers** and choose **Flatten Image**

 # More Advanced Editing

ADD TEXT TO PHOTOS

With digital photos it is possible to add text onto the photo before printing – a great way to jazz them up and add a special message to family and friends. Here's how to do it in Adobe Photoshop Elements 8.

1 Open a photo you wish to add text to

2 Choose the **Horizontal Type** tool, which looks like the letter 'T', and click on the image where you'd like the text for the message to begin. You will see a new layer open to the right of the photo. Start typing your message on the photo

3 You can change the font and size from the bar above the photo. With the type selected, use the colour menu to change the colour of the text

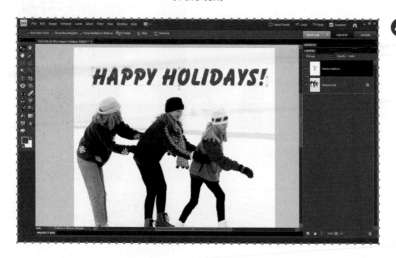

4 To move the text, click on the **Move** tool, then click on the text and, holding the mouse button down, drag and position it where you want on the image

5 Drop shadows can help text stand out from the background. To add a drop shadow, choose the **Move** tool to select the text. Choose **Layer**, then **Layer Style** and then **Style Settings**. Ensure that **Preview** is ticked, and tick **Drop Shadow**. Adjust the settings to add a drop shadow to the text

6 Text doesn't have to run in a straight line. To warp text, select the text using the **Horizontal Type** tool, and click the **Warp Text** icon in the options bar. Choose a style, such as **Arc**, from the pop-up menu and adjust the settings to suit

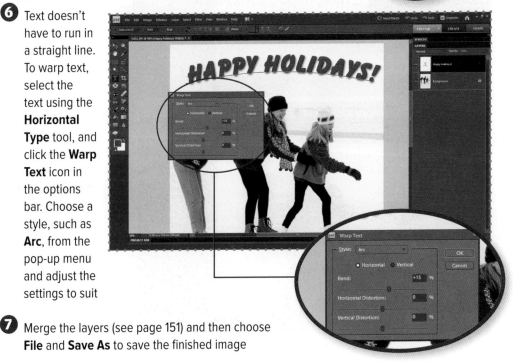

7 Merge the layers (see page 151) and then choose **File** and **Save As** to save the finished image

CREATE BLUR EFFECTS

Compact digital cameras offer many benefits, but blurry backgrounds and subjects that have a great sense of blurred motion isn't one of them. These kinds of effects are usually the domain of digital SLRs, but PC photo-editing software can replicate these effects with ease. The steps on these pages explain how to do it with Adobe Photoshop Elements 8.

The trick is to choose an image that will be enhanced by a blurry effect. A good choice is portraiture, where a blurry background would draw focus onto the subject, or a digital photo in which there's a natural sense of movement.

Selecting the area to be retained

1 Open a photo you wish to transform

2 Make a selection of the main subject – in this case, a family and sledge – using the **Lasso** tool.

3 Zoom in to 250% and click and drag the mouse to draw a line around the edges of the main subject. Don't worry if your selection goes a little awry. The next steps explain what to do

4 Zoom in close on the photo to view the accuracy of the selection. If an area has been missed off, as in this case where the man's shoe needs adding, click on the **Add to Selection** option among the small squares to the left of the Lasso's settings bar. Then click and drag around the unselected area. This will be added to the overall selection once selected

5 If you need to remove areas from your selection, click on the **Subtract from Selection** option next to the Add to Selection option and click and drag that specific part of the picture

6 Once the selection is complete, it will appear outlined by a moving dotted line. Softening the selection can make it appear more realistic. To do this, choose **Select** and then **Feather** and give it a value of 3 pixels

more advanced editing

Creating the blurred area

1 Choose **Select** and then **Inverse**. This reverses the selection so that everything in the photo, bar the main subject, is now selected

2 Choose **Filter**, then **Blur** and then **Motion Blur** so the background can be further blurred. Choose a high value to blur the background thoroughly. Choose an angle that best represents the direction of movement in the Angle value box

TRY THIS

If you've skipped the pages on working with layers, go back to pages 150–1.

3 Invert selection again by choosing **Select** and then **Inverse**. Copy the selection by pressing **Ctrl** and **C**

4 Create a new layer by choosing **Layer,** then **Layer** and then **Layer** again and call it 'foreground blur' and press **OK**. Paste the copied selection onto it. Hide the background layer by pressing its **eye** icon in the Layers panel

5 Zoom into the main subject on the 'foreground blur' layer. Using the **Quick Selection** tool, select the rear part of the image so that more blur can be added. Once selected, choose **Filter**, then **Blur** and then **Motion**

Blur and enter a value halfway between the blur value used in Step 2, opposite, and zero

6 Repeat Step 4, but expand the area to include more of the foreground of the main image. Choose **Filter**, then **Blur** and then **Motion Blur** and enter a lower value halfway between zero and the value used in Step 4

7 Select the lower layer, and hide the 'foreground blur' layer by clicking on its **eye** icon. Using the **Quick Selection** tool, select the rear of the main subject and apply another motion blur

8 Position the top 'foreground blur' layer over the main subject of the lower layer (ensure both eye icons are on)

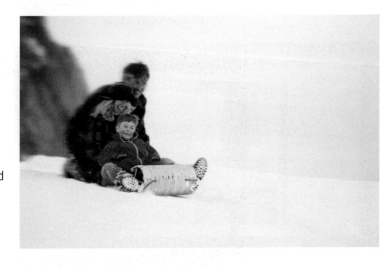

9 Merge the layers (see page 151) and then choose **File** and **Save As** to save the finished image

APPLY LIGHTING EFFECTS

Light is the most important consideration when taking photographs, but outside of a studio it doesn't always behave as expected. Adobe Photoshop Elements 8 gives a lot more control over lighting after a photo has been taken. Both ambient lighting and direct lighting can be changed.

Brightening a photo

1 Open a photo you wish to transform

2 Choose **Enhance**, then **Adjust Lighting** and then **Levels**. Select the pipette icon that has a white dropper and click on an area of the photo that should be white. Once done, click **OK**

Layers and lighting

1 Choose **Layer**, then **Duplicate Layer** from the menu. This will make a new layer appear. (See pages 150–1 for more on layers)

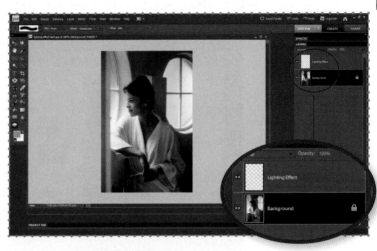

2 Rename the new layer 'Lighting Effect' and click on **OK**. It will automatically become the topmost layer

3 With this topmost layer selected, open the Lighting Filter by clicking **Filter**, then **Render** and then **Lighting Effects**. This filter is like a self-contained program and by using it you can achieve lots of different lighting effects, from simulated spotlights to washing an image with soft, omni-directional light. Try out the different effects until you achieve the result you want

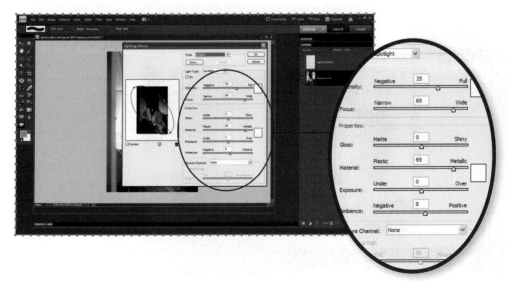

4 Use the preview pane on the left side of the filter's box to see how an image will appear if you apply the filter using the current settings

☑ Preview

5 Use the right side of the filter's box to pick other lighting styles and apply further adjustments. It is divided into four sections:
 ▶ **Style** for choosing the kind of light you want
 ▶ **Light Type** controls the light's area of coverage
 ▶ **Properties** controls reflection and brightness
 ▶ **Texture Channel** for adding texture to a lighting effect
Move the sliders to left and right to experiment with the different changes you can make to the photograph

Working with Style to create different lighting effects

1 Click on **Style** to bring up a long menu of preset lighting effects. In this case **2 O'Clock Spotlight** was chosen. It uses a spotlight to focus the light onto a point, which will be used to give the impression of more light streaming in the window

2 Using the mouse, position the centre of the spotlight circle on the subject's face and drag the edge of the circle to the top-left of the preview image. Adjust **Intensity** to suit, and increase the **Ambience Value**

3 To add a further light use the mouse to click and drag the light bulb in the lower part of the preview area onto the image. In this case, it was placed over the second window, adjusting to suit. Click **OK** to accept the settings

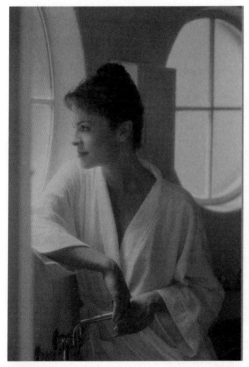

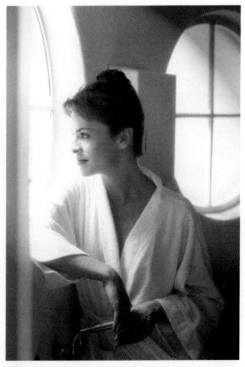

Before

After

4 Merge the layers (see page 151), then choose **File** and **Save As** to save your image

More Advanced Editing

CREATE STUNNING COLOUR EFFECTS

Colour in photography can make your photos outstanding, but often we are faced with photos that either look very dull or could benefit from some areas being a different colour altogether. Follow these steps for Adobe Photoshop Elements 8 to make fabulous colour changes to your pictures.

Changing hue and saturation

Hue is the predominant colour of a part of a photo, while saturation is how intense that colour appears – from white through to a pure colour. Boosting saturation can make colours more vivid, and adjusting the hue can change colours from, say, an orange to a red.

1 Open a photo you wish to transform

2 Click **Layer**, then **New Adjustment Layer** and then **Hue/Saturation**. Press **OK**

3 In the panel that appears called Adjustments to the right of the photo, choose the colour that you want to change or enhance

4 Using the sliders, you can adjust how vivid that band of colours (such as reds) appear in the photo using the Saturation slider. In this case, the green of the grass has been made more vivid by moving the slider to the right

5 Click on the **Master** pop-up menu, choose a colour and use the Saturation slider to enhance that colour and add more punch to an image

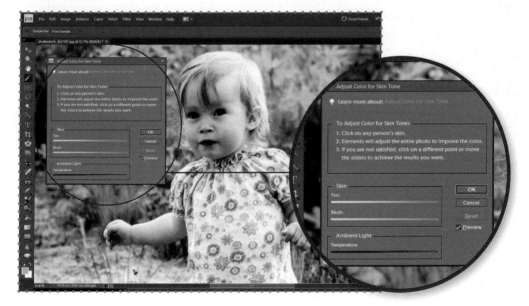

6 Adjust the **Hue slider** and **Lightness slider** to suit

Adjusting skin tone

Skin tone in photos can make people look less healthy than they actually are, especially if the colours in the image are washed out.

1 Open a photo you wish to transform

2 Choose **Enhance**, then **Adjust Color** and then **Adjust Color For Skin Tone**

3 Click an area of skin, and the skin tone is automatically improved

4 Optionally, drag the sliders to fine-tune the correction:
- ▶ **Tan** increases or decreases the level of brown in skin tones
- ▶ **Blush** increases or decreases the level of red in skin tones
- ▶ **Temperature** changes the overall colour of skin tones

5 Once done, click **OK**

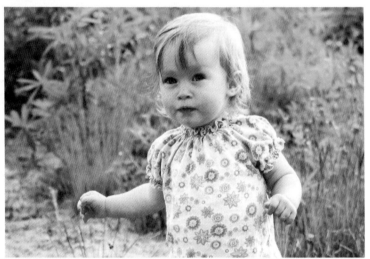

Before

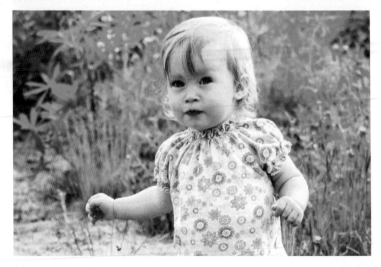

After

Selectively changing a colour

Sometimes a photo may have an element that you would like to change the colour of, such as umbrellas on a beach, the hair of a photographic subject, or the colour of someone's eyes. Some photo-editing software such as Adobe Photoshop Elements 8 include a Color Replacement Brush that makes it easy to selectively change the colours.

1 Open a photo you wish to transform

2 Hover the mouse on the **Brush** tool icon. In the menu that appears, choose the **Color Replacement** tool

3 Choose a foreground colour from the colour picker box at the foot of the tools that you want to use to replace a colour in the photo

4 Set the brush size, giving it a slightly blurred brush edge

5 Click on **Mode** in the options bar and then **Hue**. Ensure the **Anti-Alias box** is ticked, and choose **Contiguous** from the **Limits** menu. Set the tolerance to 50%

6 Paint over the coloured areas in the photo you want to change, ensuring the '+' in the centre of the brush circle remains on the colour you wish to change as you paint over the area

CREATE A PANORAMIC PHOTO

Photographing a stunning vista or cityscape is often simply too massive to squeeze into a single photo, but by stitching together a series of photographs you can create a superwide photo known as a panorama. You can do this in two ways:

1 **Using panoramic mode.** Be cautious, however, some digital cameras will simply trim the top and bottom off a standard-size photo, creating a false panoramic scene

2 **Take lots of overlapping photos,** and use photo-editing software to place these photos next to each other to create a long photo. This is known as photo stitching, and most modern photo-editing software have tools to create panoramas

Taking photos for panoramas

▶ Take lots of photos of the scene while panning the camera. Ensure that each photo overlaps the next by at least a quarter

▶ To get the best shots, it's best to use a tripod to keep the camera level as you take each picture

▶ Keep to static scenes. A series of photos of a seafront, for example, would feature lots of wave movement, making it very difficult to stitch the photos together later on

Automatically creating a panoramic scene

Photo-editing software such as Adobe Photoshop Elements 8 have special tools to automatically stitch together photos to create a panoramic scene. The great news is that it is often highly automated.

1 Name each photo file to be used for the panorama in sequential order from left to right, such as '1_city', '2_city', '3_city' and so forth

2 Open all the images that make up the panoramic scene. In this case, six photos are used. To select all the photos, press **Ctrl** and click on each of them, and then click **Open**

3 Choose **File**, then **New** and then **Photomerge Panorama**. In the screen that appears, choose **Add Open Files**. Ensure that **Auto** is selected in the upper-left of the screen. Click **OK** when done

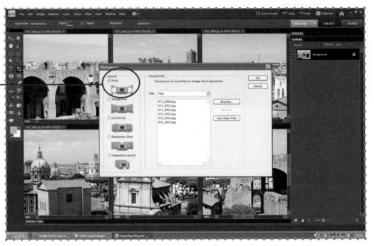

4 The photo-editor will then attempt to align the photos and blend them together into one scene, as below. If you get a near perfect result, use the **Crop** tool to cut away the edges of the scene to produced the finished result (see pages 126–7)

TRY THIS

Sometimes photos that are stitched together may contain glitches where elements don't quite overlap well. Use the guide to repairing old photos for some handy techniques on fixing these imperfections on page 169.

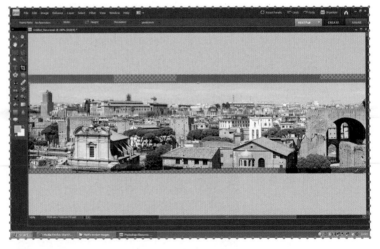

5 Flatten the image in the **Layers** palette (see page 151), then choose **File** and **Save As** to save the completed panoramic scene

Manually creating a panoramic scene

Sometimes automatic panoramic software will create a scene that doesn't look quite right. Most PC photo-editing software allows photos to be manually aligned, often resulting in a better fit.

1 Open all the images that make up the panoramic scene. In this case, six photos are used (see page 167)

2 Choose **File**, then **New** and then **Photomerge Panorama**. In the Photomerge window, select the **Interactive Layout** option. Click **Add Open Files**, and click **OK**

3 In the interactive layout window, drag and drop the photos into the main layout window, as shown below, aligning them in sequence. Ensure the **Reposition Only** option is selected in the Settings box, and that **Snap to Image** is ticked

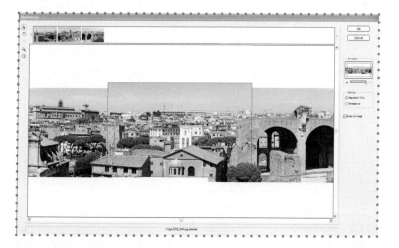

4 Using the **Selection** tool, reposition the images as needed, clicking **OK** when done

5 Crop the image as needed (see pages 126–7)

6 Merge the layers (see page 151) and then choose **File** and **Save As** to save the finished image

 # More Advanced Editing

TRY THIS

Another way to isolate the main element is to use the Eraser tool to remove the background. Choose the Background Eraser tool from the toolbar. Click on the background holding down the Alt key to 'sample' the colour you wish to erase. Drag your mouse along the area to remove – only the colour you sampled will be deleted.

CREATE A COMPOSITE PHOTO

One of the most powerful ways to use photo-editing software is to merge parts of different photographs to create a new image. Taking an element from one photo and adding it to another is called 'compositing', although it is also referred to as 'photo montage'. This technique is useful for adding people or objects taken from one photo to another one and the following steps explain how to do it using Adobe Photoshop Elements 8.

Choosing the parts you want to merge

1 Open the two photos you would like to combine. The first photo will be the background scene, while the second photo contains the element to be added to it

2 To show the two photos side by side, choose **Windows**, then **Images** and then **Cascade**

3 Select the window containing the foreground element to be added to the background photo. Double click the **Hand** icon to make this photo fill the screen as much as possible

Isolating the main element to be moved

1 Choose **Image** and then **Magic Extractor** and a new screen appears

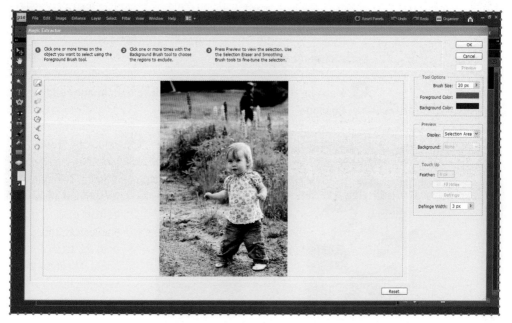

2 Use the **Foreground Brush** tool to colour over areas that you want to keep, in this case the child and path, and use the **Background Brush** tool to tell the photo-editor the areas you want to exclude. Red areas will be saved, while blue areas will be removed. Once happy, press **Preview** to see the effect

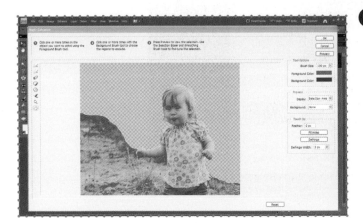

3 The preview image shows a checked background that will become transparent, in effect removing it from the photo. This means that when you move the foreground element over to the background photo, it will seamlessly appear as part of the photo. If the effect looks good, press **OK**

4 Choose the **Rectangular Marquee** tool and draw a square around the object you want to add to the background photo. Once selected, it will be surrounded with an animated line

Combining the images

1 Make both images visible using **Window**, then **Images** and then **Cascade**

2 Select the **Move** tool, then click and drag the selected foreground element from its original photo across the screen onto the background photo. Minimise the second photo so you can just see the background photo

3 Using the **Move** tool, click and drag the foreground element around the photo, placing it where you need to

4 If the cut-out element is too big or small, tick the **Show Bounding Box** in the options bar. Click and drag a corner of the bounding box that appears around the cut-out foreground object to resize it. Press the **green tick** to commit to the resize, or press the **red cross** to abandon the resizing of the foreground element

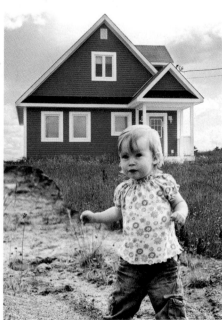

5 Merge the layers (see page 149) and then choose **File** and **Save As** to save the finished image

 # More Advanced Editing

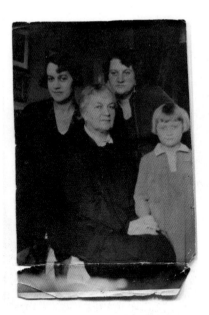

RESTORE OLD PHOTOS

Digital photography doesn't mean you have to discard photos taken long before the invention of digital cameras. Long-lost and damaged photos that you may have lurking in old shoe boxes can be given a new lease of life thanks to photo-editing software.

Scanning your photograph

1 Scan your old photograph using a scanner or all-in-one printer. Scan it in as a high a resolution as possible, as you can then enlarge the photo (which is likely to be small) to a larger 15 x 12cm (6 x 4in) print. Follow the instructions on your scanner to get the best results. Save the photo as a JPEG file and open the scanned photo in Adobe Photoshop Elements 8

Straightening

1 It's likely the the scanned image isn't perfectly straight. In order to straighten it, first choose **Image**, then **Rotate** and then **Straighten Image**

Fixing damaged areas

1 If there's an area that is badly damaged, you may to crop it out. Select the **Crop** tool and draw a square around the area of your photo you want to keep; when you're happy with your selection click the **green tick** icon (for more about cropping, see pages 119 and 126–7)

2 The Spot Healing Brush tool is ideal for removing minor flaws from photos, such as the scratch at the upper left-hand corner. Zoom in on the area you want to repair and click on the **Spot Healing Brush** icon. Hold down the left-hand button of your mouse and drag it across the area of you want to fix (see pages 142–3)

3 To fix bigger areas of damage, such as around the bottom of the photo, click on the **Clone Stamp** tool. Chose a medium-sized Basic Brush from the options bar for the repairs. Position the cursor in the area of the picture to copy. Hold down the **Alt** key and click with the left-hand button on the mouse. The cursor will change to an icon that looks like a target

4 Position the mouse over the damaged area and click again to paste the copied section. Repeat until all damaged areas are repaired. Continue to use both tools to repair other areas

more advanced editing

 # More Advanced Editing

Editing with Quick Fix

1 Once the damaged areas have been repaired, click on the orange **EDIT Full** tab and select **EDIT Quick** to get to Quick Fix. Here there are tools that will automatically adjust aspects such as the shadows, saturation, hue and temperature

2 Click **Auto** on Smart Fix or use the slider. In the View drop-down menu in the lower left of the screen, choose **Before & After - Horizontal** so that you can see how the enhanced photo looks compared to the original

3 When you're happy with the result, select **After only** in the View drop-down menu

TRY THIS

The Quick Fix window contains a range of tools that are designed to quickly and easily correct colour and lighting issues in photos. Try them out until you find a balance that works for you.

4 Choose **File** and then **Save As** and save the final photo. Your restored picture can be printed as with any digital photograph

SHARING PHOTOS

By reading and following all the steps in this chapter, you will get to grips with:

▶ **Sending photos via email**

▶ **Sharing photos online**

▶ **Ordering photo gifts online**

▶ Sharing Photos

SEND PHOTOS BY EMAIL

Sharing photos with family and friends via email is relatively straightforward. To attach a photo to an email in Windows Mail:

1 Click **Create Mail**. A new window will appear

2 In the **To** box, type the email address of the person you're writing to or select the person from your address book/contacts

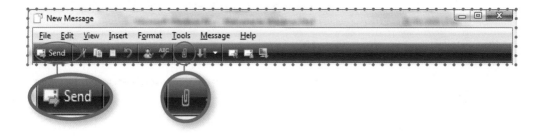

3 Once you've written your email, click the **paper clip** icon

4 Locate the file you want to send and click on it. Photographs are likely to be in your Pictures folder

5 Click **Open**

6 The file will appear in the Attach box

7 You can add more photos to the email in the same way. When you have attached them all, click **Send**

QUICKLY RESIZE PHOTOS FOR EMAIL

Digital cameras can generate extremely large image files that may clog up another person's inbox (and your own sent box) if you attach them to an email in the form in which you transferred them to your computer. The large size of an image might even mean it gets sent straight to the recipient's junk mail folder or is blocked altogether. Even if the recipient can view the picture, it may be so large that they have to scroll up, down and across to see the whole image.

Windows Live Photo Gallery lets you resize pictures for easy emailing. This involves altering their resolution. When emailing a picture, consider what the person receiving it wants to do with it before choosing an image size (see Step 4).

1 Click **Start**, then **All Programs** and then **Windows Live Photo Gallery**

2 Click on the picture you want to email

3 Click **E-mail** at the top of the window

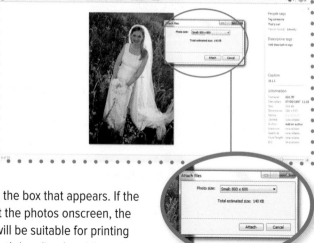

4 Choose the size you want from the box that appears. If the recipient will only be looking at the photos onscreen, the 'smaller' size is fine. This size will be suitable for printing photos at 10 x 15cm (4 x 6in). Both 'medium' and 'large' are suitable for printing photos sized 12 x 18cm (5 x 7in)

5 You will then see the estimated size of your attachment. Anything less than 1MB is fine to send via email

6 If it's OK, click **Attach**

Sharing Photos

OPEN PHOTOS IN EMAIL

To open a picture or document attached to an email that you have been sent:

1 Double click on the **email message** that contains the attachment

2 Double click on the **file attachment** icon at the top of the message window

3 The attachment will open in a new window and you can save it from here

4 To save an attachment before opening it, open the message as above and click **File** in the message window

5 Click **Save attachments**

6 A folder list will appear. Select the folder into which to save the attachment

7 Select the attachment you want to save (if there's more than one)

8 Click **Save**. Repeat for other attachments, if there are any

SEND A SLIDE SHOW VIA EMAIL

Rather than sending an email with a number of individual photographs, which can be cumbersome to open and view, consider sending friends and family a photo slide show. It will play automatically when the email is opened and photos will be viewed in the order you want.

Creating a slide show

A good way to create a slide show is to use an image editor such as Adobe Photoshop Elements 8. In this program, you can create a slide show including a wide range of transitions (the moment when the slide show moves from one photo to the next). When the show is complete, you can compress the file to a smaller size as a PDF document to email it to your family and friends.

Choosing images to include

1 Click on the **Start** button and click on **All Programs**. Click on **Adobe Photoshop Elements 8**

2 From the Organizer, press **Ctrl** and click on the images you want to include in the slide show

3 Click the purple **Create** tab on the top right-hand side, then click **Slide Show**

Choosing the transitions and duration

1 The **Slide Show Preferences** box will appear, complete with a thumbnail of the first slide you have chosen

2 A number of options will also appear and each should be self-explanatory. You can, for example, choose the length of time that each slide remains on show, along with how one slide will transform into the next and how long that transition will take

3 When you're happy with your selections, click **OK** and you are then taken to the **Slide Show Editor** box

Changing the slide order, add or delete slides

1 The **Slide Show Editor** box shows you an overview of the slide show. You will see thumbnails of the images in order, any transitions you have selected, and the static duration for each slide

2 You can change the order of the slides by clicking on them, holding down the button and dragging them to where you want them before letting go

3 If you wish to delete an image, right click the thumbnail and select **Delete Slide** from the menu that appears

4 You can add images easily too. Click the **Add Media** button close to the top of the box

5 Select **Photos and Videos** from Folder and then navigate to your folder of images. Press **Ctrl** and click on the photos or video you want to add from your folder. Click **Open**. The photos or video will be added to the slide show

6 The default setting is a two-second fade and is usually fine for most slide shows. You can select from many different types of transitions to make your slide show stand out, and there's even a random option

7 To change from the default transition, click on the small black arrow to the right of the transition's icon and select a new type from the pop-up menu, such as **Dissolve**

8 To apply the same transition to all the slides at once, select the same small black arrow and then choose **Apply To All** from the pop-up menu

Saving the slide show as a PDF

1 Once you're happy with your selections, click the **Output** button close to the top left of the box

2 The **Slide Show Output** box will appear. You can save your file as a PDF, as well as select the slide's image from the pop-up menu

3 Select the **Small option** of 800 x 600 pixels so that the slide show can be sent by email

 # Sharing Photos

SHARE PHOTOS ONLINE

Email is fine for sending several photos at a time, but you may wish to share all the images you've taken of a recent holiday or family occasion such as wedding. The best way to do this is to create an online photo album.

There are dozen of photo-sharing websites that allow you to upload and display your personal images. Only those who have been given a link by you can view your photos.

Many websites are free, while others charge a fee or require you to order prints to keep your account active. Most are easy to use and share similar features.

▶ All photo-sharing sites require you to register first. This usually means giving your name, email address and a password

▶ Once registered, you can start uploading photographs and putting together individual albums. Albums can be created around any topic

▶ You can add captions to your photographs and personalise albums by changing backgrounds designs. You can also crop, resize and even add special effects on the page

▶ When you've finished creating your album, you can invite others to view it by sending them a link in an email. They simply click on the link to open the specific page on the photo-sharing site that has your album on it

SHARE YOUR PHOTOS ON FLICKR

Follow these steps to post pictures on Flickr, a popular photo-sharing website.

Creating a Flickr account

1 You need a Yahoo! Account to use Flickr. To create one, go to the Flickr website www.flickr.com and click **Create Your Account**

2 This takes you to the Yahoo! sign-up page. Click **Sign Up** (on the bottom right-hand side of the page), enter your personal details then click **Create My Account**

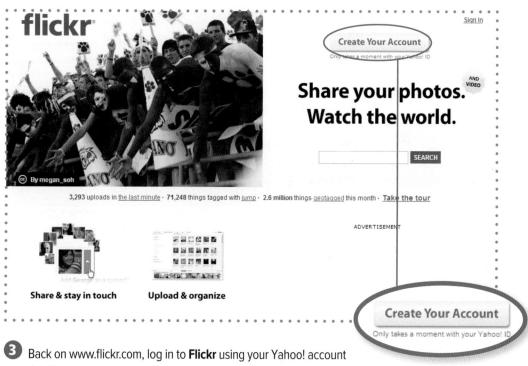

3 Back on www.flickr.com, log in to **Flickr** using your Yahoo! account details

4 Select a screen name and click on **Create a new account**

Sharing Photos

Uploading photographs

You can now start transferring your photos from your computer on to the website – a process known as uploading.

1 On the welcome screen click **Upload your first photos** (whenever you return to the site from now on, just click **Upload Photos and Videos** in the top right of the screen once you've logged in)

2 Select **Choose photos and videos**. This will open a window that will enable you to browse your computer for your photos

3 Select a photograph and click **Open**. Your photo will appear on the Flickr web page

4 Select whether you want this picture to be private, whether you want your friends and family to be able to view it or whether to make it public and allow all Flickr users to see it

TIP

When you log in to Flickr, click **Your Photostream** on the main page to see your pictures.

5 Click **Upload Photos and Videos**

6 Add a brief description of the photos and any tags by clicking on **Add a description**

Describe this upload

Or, open in Organizr for more fine-grained control.

• Batch operations

Add Tags [?] Add to a Set Create a new Set...

[] [ADD] [You don't have any sets yet ⌄]

• Titles, descriptions, tags

Title:
[Woman group]

Description:
[This is my friend]

7 Once you've done this, click **Save** or, if you've uploaded more than one photo, **Save this batch**

Giving access to your photos

Once you've uploaded your photos, you can set up your own Flickr web address that you can give to friends who want to look at the photos.

1 When you're logged in on the Flickr website, click on the arrow next to You in the menu bar at the top

2 Click **Your Account**

3 Click **Create your own memorable Flickr web address**

4 Complete your web address (make this up yourself) in the box that appears. Click **Preview**

5 Make sure that it's correct, then click **OK – Lock it in**

6 Now you can give your new address to friends to view your photos

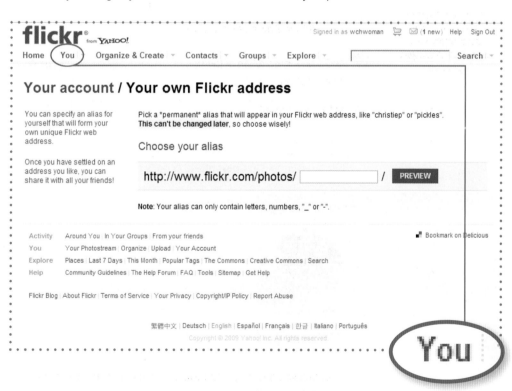

187

MAKE A PHOTO CALENDAR

While countless online photo-printing services offer calendar printing at low cost, you can create and print your own calendar for much less using software such as Adobe Photoshop Elements 8.

Downloading calendars

Before you start making your calendar, you'll need to find some downloadable monthly calendar dates, because creating these manually would be painstaking. There are plenty of places online where blank calendars can be downloaded free of charge.

One of the best sites is PDF Calendar (www.pdfcalendar.com), because each month is available as a PDF file. PDF is an ideal file format for creating a calendar. For this example, each calendar month has been downloaded in landscape A5 format to work with an A4 size calendar.

TRY THIS

When choosing digital images for your calendar, make sure they are large enough to be printed at 300 pixels/in across the width of your page (see pages 24–6).

Importing a print calendar

Once you've downloaded all 12 months from PDF Calendar, you're ready to create a 12-month printed calendar.

① Click **Start**, then **All Programs.** Click **Adobe Photoshop Elements 8** and then click **Edit** to open the Full Edit window

② Click **File**, then **New** and then **Blank File** to open a new document. In Name, enter **January**. In this example portrait A4 size is being used, which is 210 x 297mm. Give it a resolution of 300 pixels/in and in **Color mode** choose **RGB**. Then click **OK**

③ Unlock your document's single layer. Go to **Windows** and then **Layers** and double click the layer. It should now read 'Layer 0'

④ Go to **File** and then **Place**, and navigate to your downloaded PDF file for January. Click on **Open**

⑤ In the resultant Import PDF window, there are options to choose 'Page' or 'Image'. Select **Page**, and click **OK**

6 The PDF is already the right width for your page (as shown above, left), so all you have to do is position it precisely in the bottom half of your A4 document (above, right). The top half is for the image

7 When you're happy with the position of your January file, click the **Tick** icon to confirm your changes, and then flatten the image (click on **Layer** and then **Flatten Image**) to give the PDF a solid white background instead of a transparent, checkerboard one

Adding a calendar image

1 To place an image, click on **File** and then **Place**. Here, a seasonal shot of the family in the snow has been used. It needs to be a landscape-shaped image, because a portrait-shaped one will be too narrow and deep to fit the space

2 Position the image above the dates for January, and drag the handles on the image (see page 127 and right) until it bleeds off the edges of your A4 document. Click the **Tick** icon to confirm your changes

> ### Jargon buster
>
> **Bleed**
> A print term, bleed describes printing – either an image, text or colour – that extends off one or more sides of a paper sheet leaving no margin or border when trimmed.

Creating templates for other months

Much of the work you've done for January will serve as a template for the other months.

1 Click on **File** and then **Save As** 11 times – one each for the remaining months – giving each new file a unique month name and saving them in the same location

2 Import the relevant PDF calendar for each month (see Steps 1 and 2 on page 188), and select a suitable landscape-sized image

Printing photo calendars

An inkjet printer is much better for this kind of printing than a laser, because it is able to print higher quality printed images.

1 To maximise print quality, you have to select specific print settings. Go to **File** and then **Print**

2 Click on **More Options** and then **Color Management**. In the Color Handling menu choose **Printer Manages Color**. In Rendering Intent, select **Perceptual**

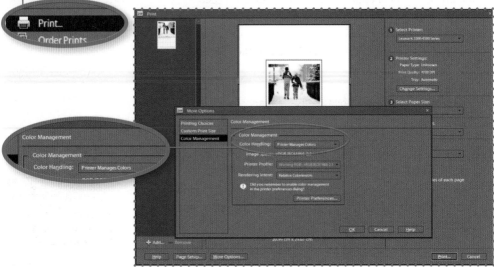

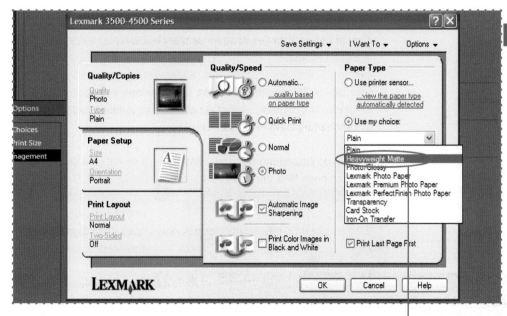

3 In the Colour Preferences part of the Print window, click **Printer Preferences**. The layout and contents of printer preference windows differ from user to user, depending on what make and model of printer is being used. However, all printer preferences offer an option to choose paper type. You'll need to print to a matt photo paper. This is a calendar, so you'll need to write on it, and matt paper is easier to write on than glossy photo paper. Most paper-type menus in printer preferences are called 'Media' or 'Paper'

Putting your calendar together
When you have all 12 printouts, you need to compile them into a calendar.

1 Measure the top-centre point on the January printout

2 With the other months lined up precisely underneath, punch a single hole at this point through all 12 months with a hole puncher

3 Thread a small key ring loop through the holes. This not only holds your calendar together and gives you something to hang it up with, but also makes it easy to flip over the months. That's it – your calendar is complete

NEXT STEP ⊙

For more information on printing options, see pages 202–14.

CREATE A PHOTO CALENDAR ONLINE

Most photo-printing services online offer the ability to design and create a calendar using your own photos. This will then be printed and sent to you via normal postal mail. Not only will your calendar make your family smile for the rest of the year, making a calendar is also a great way to help them remember all those important anniversaries. In this example Snapfish has been used.

Setting up your calendar

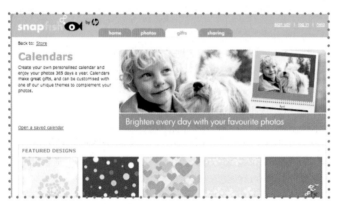

1 Go to the Snapfish website (www.snapfish. com). Click **Sign Up** and enter your details

2 Select the **Home** tab then **Upload photos**. Enter an album title and click **Upload to this album** and follow the onscreen instructions

3 Should you need to come back to your browser again later on, log in then click **Upload photos** and re-enter your album name

4 Click **Select photos**. Browse to the desired pictures on your computer and click **Upload photos**; clicking **Select more** to add additional pictures to the online folder (here it's called 'Calendar'). Keep adding photos to this folder until you have enough pictures. You can use multiple images per month, so don't limit yourself to just 12 pictures

5 To make your personalised calendar, click on the **Gifts** tab and click the **Calendars** link. Select a style for your calendar, choosing whether you want to make a 12- or an 18-month calendar and select a start date (for example, January 2010)

6 Click **Create this calendar** and then click **Get photos** to use in your calendar. Select the **Calendar folder** and click **Get all**. Click **Done**

Creating your calendar

1 Drag and drop images from the thumbnails on the right-hand side of the screen into the space on your calendar's cover. You can also click on the text box underneath the image and type in a title for your calendar. A fictional family name has been used here: 'The Robinsons 2010'

2 You can add memorable dates such as birthdays and anniversaries to your calendar. Double click on a date to launch a separate box. Drag and drop a picture from your thumbnails into the space for the picture and enter your text in the space provided ('Happy Birthday' or 'Happy Anniversary', say), then click the yellow button marked **Done**

TIP
To move to the next page of your calendar, click the **Next** button.

3 To change the background on your calendar, select the **Background** tab and click on the underlined links to select a theme. To apply a background from your chosen theme, drag and drop the thumbnail image onto the calendar

4 To change the layout, click the **Layout** tab and drag and drop the thumbnail matching your desired layout onto the calendar image

5 You may find that when you drag a picture into the space in your calendar it appears the wrong way round. To edit a picture, hover your cursor over the image and click on the **small paintbrush** icon. In the resulting box you'll see a series of icons that allow you to rotate, flip and zoom in and out. By hovering your cursor over the icons you will reveal their functions

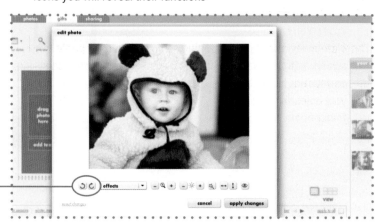

6 Once you've added pictures to all of the months within your calendar click the **Preview** button and use the **Previous** and **Next** buttons to scroll through your design

7 Once you're happy with everything, click **Done** and then follow the instructions for ordering and paying. Your calendar should be delivered in 4–8 working days

CREATE A PHOTO BOOK ONLINE

As with film, you can print out your digital photos and put them in traditional albums. But this old-fashioned approach to photo sharing can't compete with printing your own photo book. Thanks to the internet and digital printing, it is now relatively inexpensive and easy to create a professionally bound keepsake of a favourite holiday or precious family occasion.

There are many online photo-printing services that offer photo book creation but they all share the same basic premise: you choose a style, upload your photos and arrange them on the pages, add captions and text, and finally arrange printing. Here's how to create a photo book using Snapfish.

1 Log onto Snapfish as described on page 192

2 Find photo books through the store link

3 On the next page, you'll see lots of different styles and types of book including hardcover, softcover and even children's Picture Me photo books. Choose the type of photo book you wish to create and click the **Get Started** button under the name

4 On the next page, choose a background colour and design for the pages. Click on the picture of the design you want to continue

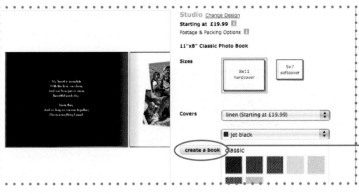

5 Next choose a fabric for the cover of your book. Then click **Create a book**

6 Before you can virtually place your photos on the pages of your photo book, you need to upload them to Snapfish. Click **Get Photos** on the right-hand panel

7 Create a new album for your photos. Give it a name, date and description, then click **Select photos** to browse for photos you wish to upload

8 Once your images are uploaded, you will be asked whether you want your photo book filled automatically with these images. If you want to place photos individually then click **No Thanks**

Creating your photo book

1 Add your photos one by one to each page. You can choose from a variety of different layouts for each page and have up to 15 different images on a single page

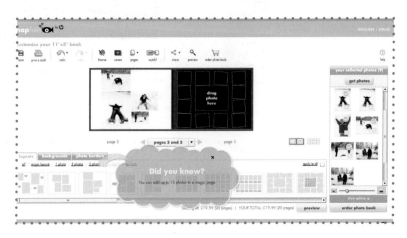

▶ Sharing Photos

2 You can add captions to images in a variety of styles, sizes and formats. Click through to see which one you like

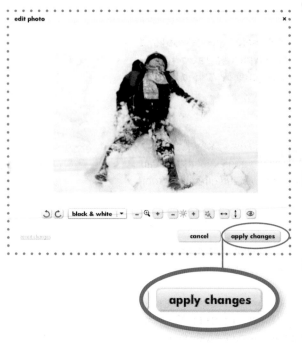

3 Click on a photo to either edit or delete. Clicking **Edit** brings up a box where you can apply colour effects to your photo, including black and white and sepia, alter brightness, zoom, flip images either horizontally or vertically and remove red eye. When you're happy with the results click **Apply changes**

4 When all your photos and captions are placed, click **Preview** to enjoy the contents of your photo book

5 Once you're happy with everything, click **Done** and then follow the instructions for ordering and paying. Your photo book should be delivered in 4–8 working days

CHOOSING A DIGITAL PHOTO FRAME

A digital photo frame is a great way to show off your family photos as it can cycle through a slide show of your favourite images, often with eye-catching transitions between images. Some digital frames can even show short video clips with sound. Here is information on what to look for when buying a digital photo frame.

Frame size

▶ The most popular frame sizes are 18, 20, 23 and 25cm (7, 8, 9 and 10in), but 30 and 38cm (12 and 15in) frames are becoming more widely available as the technology improves

▶ The size is measured diagonally, like TV screens, and resolution generally increases in line with frame size, but not always

Image resolution

▶ A digital photo frame's resolution is measured in a 'pixel by pixel' format. A frame with a resolution of 800 x 480 (384,000) pixels has three times more pixels than a 480 x 234 (112,320) model

▶ For the best clarity, look for the highest resolution. A typical 'wide VGA' (WVGA) resolution is 800 x 480

Image brightness

▶ The maximum image brightness of a digital photo frame is measured in candelas per square metre (cd/m^2), and a typical value for a digital photo frame is $200cd/m^2$. A higher figure is generally better, but this is not the sole indication of image quality

Viewing angle

▶ Digital photo frames suffer from the same problem as most LCD screens: limited viewing angle. A wide viewing angle means you can see the image on the screen without having to stand directly in front. A typical value is 160 degrees

Image enhancement

▶ Some digital photo frames have built-in image enhancement functions and you can also copy, delete, rotate, zoom and crop

Display options

▶ Just about all digital photo frames offer slide show options. You can vary the time a photo stays up and choose a favourite transition to go from one to the next

TRY THIS

Digital frames are far more intrusive than print frames because of their picture changing, so be careful to choose the size that's right for your room

Control buttons
- ▶ The frame should have simple, easy-to-use controls. They should be clearly labelled and accessible – ideally on the top of the frame

TRY THIS
Touch-sensitive controls are becoming more widespread on digital photo frames. These are embedded in the edge of the frame, and icons illuminate when they sense your finger.

Memory cards
- ▶ Many digital photo frames have a built-in memory so that you can copy photos straight from your computer or camera to the frame
- ▶ If there's no internal memory, you'll need to leave your memory card inserted in the frame
- ▶ Digital frames can accept most types of memory cards. Check the frame you plan to buy is compatible with the card used by your camera

Common digital photo frame connections
- ▶ **Wi-Fi** Some digital photo frames can connect to a wireless (Wi-Fi) network so you can stream pictures direct from your computer or send them directly to the frame via the internet or email
- ▶ **TV Out** A TV Out connection on a digital photo frame lets you display your photos on your TV
- ▶ **HDMI** An HDMI socket on a digital photo frame allows it to be connected to an HDTV so that your photos display on the larger screen of the TV in full high-definition resolution
- ▶ **Bluetooth** This lets you send or copy photos from a Bluetooth compatible device, such as a mobile phone, straight to the frame
- ▶ **USB** This allows the digital photo frame to be connected directly to a computer for file transfer

USING A DIGITAL PHOTO FRAME

Organising the pictures

When you have selected the photos you'd like to display on your digital photo frame, copy and paste them into a single folder.

1 Right click on your **Desktop** and select **New** and then **Folder**

2 Press down the **Windows** key, which is likely to be two keys away from the space bar on your keyboard, and **E** to open Windows Explorer

3 Find the pictures you want, right click and select **Copy**

4 Open your desktop folder, right click and select **Paste**. All the pictures in your desktop folder are copies of those on the hard drive

TRY THIS
Some digital photo frames will automatically rotate your photos so they are displayed the right way up.

Changing picture orientation

If your digital photo frame is set up to sit landscape, then all the pictures that you put on there will also need to be set up for landscape.

To flip a picture in Windows Live Photo Gallery, use the rotation controls at the bottom of the window to rotate it in the right direction.

Transferring your pictures

You'll need to save the pictures you want to display on your photo frame to a memory card – your digital photo frame may come with one.

1 Insert the card directly into your computer, if possible, or into a memory card reader (see page 34)

2 Press the **Windows** key (see Step 2, above) and **E** and locate the card or device. Then drag and drop the folder of pictures you created to this card

3 Insert the card into the slot in your digital photo frame and your happy snaps will be ready to be shown off to family and friends

▶ Sharing Photos

VIEW PHOTOS ON TV

Most digital cameras come with a Video Out cable. By plugging one end into your camera and the other to your TV set, you can view photos on a big screen – perfect for sharing with a roomful of friends and family.

1 Refer to your digital camera manual to locate the camera output port (this may be called Video Out, AV Out, or simply AV). The output cable has a single connector that plugs into the camera while the other end has three connectors in three different colours: red, white and yellow

TRY THIS

Power your camera using an AC adapter if possible, as playback mode can drain batteries quickly.

2 Turn off your digital camera and TV set

3 Insert the memory card into your digital camera that contains the photos you would like to view on your television

4 Plug the cable that came with the camera into the Video Out socket

5 Plug the cable's three connectors into your television set matching the colours of the connectors to those ports on the TV. The red, white and yellow ports can be located either at the back of your TV, on the side or in the front

6 Turn on your TV and set it up to receive external input

TRY THIS

Another way to view your digital photographs on a TV set is to burn them to a DVD and play in a DVD player.

7 Turn on your digital camera and put it in playback mode

8 Enable your digital camera's slide show mode or use the normal camera buttons to view images one by one

PRINTING PHOTOS

By reading and following all the steps in this chapter, you will get to grips with:

▶ **Printing from your home printer**

▶ **Ordering prints online**

▶ **Printing from a photo kiosk**

▶ Printing Photos

TRY THIS

Some high-street stores have self-service photo kiosks, which let you select and print images from your memory card yourself (see page 214).

PRINTING OPTIONS

When it comes to printing your digital photos, there are lots of ways to get good quality prints.

▶ **Print at home,** which is the quickest option. Using either a photo-quality inkjet or photo printer, you can print from your computer or directly from a memory card. When used with special paper, the quality of prints from modern printers is very good (see pages 205–6)

▶ **Print at a shop** where digital photo processors are widely available. You simply hand over your memory card or CD and decide which images you want printed in what sizes. Many firms can give your prints back within an hour

▶ **You can post photos** on a memory card/CD or on a CD to some photo print companies, with an order form, and they will send your card and prints back within a few days

TRY THIS

If you send your memory card away, make sure you have another one if you want to take more pictures while the original is being processed.

▶ **Online printing services** To use these, upload your digital photos to a print provider's website (see pages 210–13). They are then printed and the prints sent to you via the regular postal mail. Most online print companies provide excellent quality prints and offer a wide range of extra print options such as enlargements, or printing

CHOOSING THE BEST PHOTO PRINTER

If you decide you'd like to print your photographs at home, you have a couple of options. You can buy an inkjet printer that will print onto standard A4 office paper as well as special photo paper of varying sizes or you can go for a dedicated photo printer. These are much smaller but print only photos. Dedicated photo printers use two types of technology:

▶ **Inkjet photo printers** uses a series of nozzles to shoot minuscule droplets of ink directly onto paper to build up an image. The images inkjet printers produce consist of thousands of tiny dots, each smaller than the diameter of a single human hair. They tend to be quieter than dye-sublimation models

▶ **Dye-sublimation photo printers** use one large ribbon cartridge containing three panels of colour film. The paper runs in and out of the printer three times and the colours are transferred to the paper separately on each pass. Photos from these printers are touch dry and slightly more water resistant than those produced by an inkjet printer. But dye-sublimation printers make a whining noise when printing that some may find irritating

Printing from a memory card

The easiest way to print snaps is to use the memory card slots on the printer. Simply take the memory card from your digital camera or mobile phone, insert into the machine and press print. Check that the printer you want to buy takes the type of memory card used by your camera.

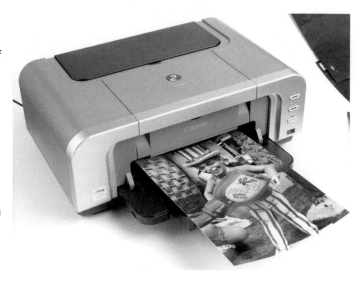

Printing from a computer

As with a standard printer, you can connect your small photo printer to your home computer using a USB cable. Printing like this often results in a higher quality result than printing direct from the memory card.

Printing Photos

Running costs

You'll spend more than £100 on a decent small photo printer, but the expense doesn't end there. You need to buy photo-quality paper and ink cartridges, which can work out quite expensive. It could, for example, cost you as much as £37 to print 100 photos. So it makes sense to choose a printer that won't cost the earth to use. Even so, it's almost always cheaper to get your photos printed at a high street or online retailer.

Photo printer features to look for

▶ **A PictBridge connection,** which lets you plug your digital camera into the printer directly using a USB cable, so you don't have to transfer photos to your computer first. Look for the PictBridge logo on the device or in the instructions

▶ **Docks and photo printers with docks** Some printers have docks that let you click your camera onto the printer directly so you can select and print your photos. Docks work only with particular cameras, usually those from the same manufacturer. Docking station photo printers are becoming less common as many have now been replaced by memory card slots and PictBridge connections that are more versatile as they work with a wider range of cameras

▶ **LCD screens** Compact photo printers have LCD screens that allow you to preview your images when printing directly from a memory card. Large LCD screens are easier to view and edit images on. Some more expensive models use touchscreen technology

▶ **Some printers come with batteries,** which gives you more flexibility and allow you to print away from a mains power supply

PRINT FROM WINDOWS LIVE PHOTO GALLERY

You can print photos directly from Windows without first opening them in My Pictures, but Windows Live Photo Gallery offers features that the Pictures folder doesn't have, such as the ability to fix the exposure and colour of a picture, crop it, and remove red eye (see pages 118–20).

1 Click **Start**, then **All Programs**, and then **Windows Live Photo Gallery**

2 Click **All Photos and Videos**, and then click **My Pictures** in the left-hand info pane

3 Click on the photo you want to print

4 Click **Print** on the top menu, and then click **Print**

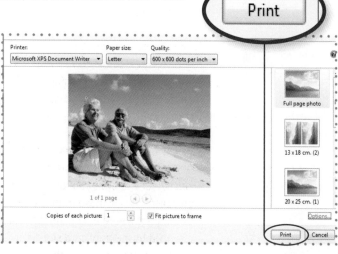

5 In the Print Pictures box, select the printer you want to use

6 Select **Paper size**

7 Select print **Quality**

8 Select **Print Style**. You can print a single picture, print multiple pictures on one page or print a contact sheet (a grid of thumbnail pictures for easy reference)

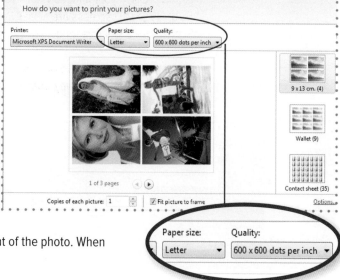

9 Finally select the number of copies you want of the photo. When you're done, click **Print**

Printing Photos

PRINT FROM ADOBE PHOTOSHOP ELEMENTS 8

If you have Adobe Photoshop Elements 8 installed on your computer, you are able to print photos to a home printer directly from within the software.

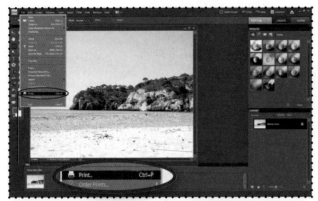

1 In Adobe Photoshop Elements 8, cick **Edit** to open the **Editor**

2 Open the photo you want to print in the Editor. From the top menu bar click **File** and then click **Print**

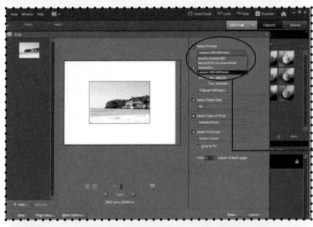

3 Choose a printer from the **Select Printer** menu. You can also click the **Page Setup** button to specify page printing options

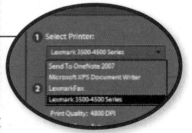

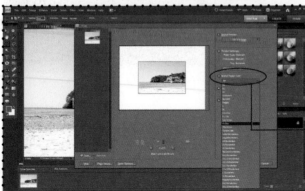

4 Select the size of the paper you wish to print on from the **Paper Size** menu

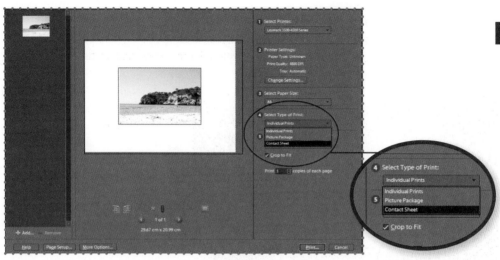

5 Choose the type of print you wish to make from the **Select Type of Print** options:

> ▶ **Individual Prints** gives you a single photo
> ▶ **Picture Packages** gives a page of one or more photos printed at various sizes
> ▶ **Contact Sheet** allows you to print thumbnails of selected photos by clicking. Choosing this option will take you to Element's Organizer where you can select multiple photos to print

6 Select a print size from the **Select Print Size** menu. Click **Custom** if you want to specify a particular size print. Enter a number in the **Print Copies Of Each Page** textbox

7 To fit your photo to the specified print layout, select **Crop To Fit**. Your photo will be scaled and, if necessary, cropped to match the aspect ratio (see page 127) of the print layout. Untick this box if you don't want your photos cropped

8 Click **Print**. Your photos are sent to the printer using the options you selected

TRY THIS

You can access additional print setting information such as adding the date and a caption to your printed photo by clicking the **More Options** button at the bottom of the print box.

Printing Photos

PRINT PHOTOS ONLINE

Online print processors, such as Bonusprint, Photobox and Snapfish, take a number of days to deliver your prints, but they do come to your door. They're often the cheapest way to get large volumes of printing done. Many online services will also allow you to store your photos in an online album so you can come back and view them at a later date.

To use an online printing service, visit their website and follow their instructions. In this example, Bonusprint has been used.

TRY THIS

You can send links to friends or family with some online albums so they can look at your photos too (see pages 184–7).

Uploading your pictures

1 Type www.bonusprint.co.uk into the address bar of your web browser and press enter. Click **Digital Photos**

Digital sizes		Prints	Price
4"x5.3" (10x14cm) Glossy / Matt		1 - 99	10p
		100 - 199	7p
		200+	5p
Doubleprint prints		1 - 99	12p
		100 - 199	9p
Glossy	For size info click here	200+	7p
4.5"x6" (11.5x15cm) Glossy / Matt		1 - 99	12p
		100 - 199	9p
		200+	7p
5"x6.6" (13x17cm) Glossy / Matt		1 - 49	17p
		50 - 99	14p
		100+	10p
6"x8" (15x20cm) Glossy / Matt		1 - 9	29p

2 On the next page, you'll see a list of print sizes for digital and the price per print, which will vary depending on how many prints you order

③ Click the **Upload Your Photos** button

④ Bonusprint will now request that you download its Image Uploader Java Applet. This is a little piece of software that allows you to select and upload your photos quickly and easily. The download will begin immediately but you need to click **Allow** when you will see the installation box to grant permission for your web browser to install this applet

⑤ With this installed, you can now select and upload images from your computer

⑥ The left-hand panel shows the photos stored on your computer. Select a folder to view the photos inside

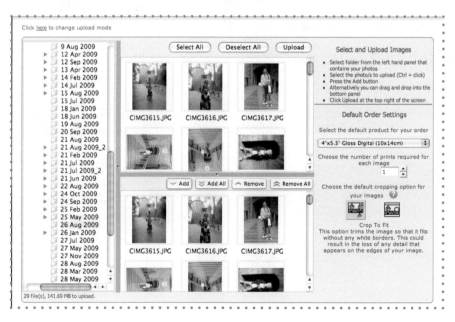

7 Clicking on an image will bring up three icons – two **rotate** buttons that let you change the orientation of your photo and a **zoom** button that lets you preview the photo in more detail

8 You can choose to select all the images in a folder by clicking **Select All** and then clicking **Add**. All the photos in the folder will then appear in the panel below

9 To select photos one by one, click on an image. A square will appear around the photo to indicate it has been selected. To select more than one photo at a time, hold down the Shift key when clicking on photos. Then press **Add** for them to appear in the panel below

Placing your order

1 Choose the size of the print and the type of paper it will be printed on. Bonusprint offers a huge range of print types from glossy and matt papers to canvas, card and even mugs, jigsaws and T-shirts

2 Choose the number of prints you wish to have of each photo

3 Select the default cropping option for your printed photos

4 When you've finished, click **Upload**. When the upload is complete, click **OK**

5 The next screen will show your basket. You can view your photos and remove any should you change your mind about printing them. You can change the number of prints per photos, change the type of print required and upload further photos

6 When you are happy with your selection, click **Checkout**

7 Enter your contact details and postal address and then click **Next**

8 Confirm your delivery and order, then click **Place Order** to be taken to the WorldPay Secure Server, where you complete your order by entering your credit card/debit card details

9 You will receive confirmation of your order by email and your prints should be delivered within 2–7 days

▶ Printing Photos

USING A DIY PHOTO KIOSK

Touchscreen DIY photo kiosks are available in some shops. You simply insert your memory card or CD and print your photos yourself in the store, with the option of some basic editing such as adjusting brightness, cropping or red-eye reduction.

Your pictures will usually start to come out of the machine within a minute or two, though sometimes you may have to wait a bit longer

You can usually only print 15 x 10cm (6 x 4in) or 20 x 15cm (8 x 6in) pictures and they can be a little on the pricey side, but they're perfect when you just want a couple of images in a hurry.

Using a kiosk

1 View the images before you go to the store so you know of any problems, such as red eye, that you will want to correct at the kiosk

2 Either copy the images on to a CD/DVD or take along your camera's memory card. Kiosks will recognise most types of card

3 Insert the memory card or disc into the kiosk and use the touchscreen to select the images you want to print

4 If you want to do some basic editing, such as cropping and removing red eye, you can do that now

5 Select the size you require, specify the finish you want (matt or glossy, for example) and the number of prints you need. Prices will be displayed for you to check. When they have been processed, the photos will drop into a tray at the bottom of the machine. In most shops you pay at the till

JARGON BUSTER

▶ Jargon Buster

Ambient light The natural light in a scene.

Aperture A small, circular opening inside the lens that can change in size to control the amount of light reaching the camera's sensor as a picture is taken.

Aperture priority A semi-manual exposure option. The user sets the aperture according to the depth of field they require and the camera sets the shutter speed to obtain the correct exposure.

Aspect ratio Refers to the relationship between the width and height of a digital photograph. For example, if a photo has an aspect ratio 2:1, it means that the width is twice as large as the height.

Automatic mode A setting that sets the focus, exposure and white-balance automatically.

Artifacts A flaw in a digital photo caused during the compression process.

Backlighting Occurs when your subject is brightly lit from behind, making it difficult to set the correct exposure. Unless you adjust the camera's exposure to compensate, the subject will appear as a dark silhouette against the bright background.

Bicubic To enlarge a digital photo in size or resolution, photo-editing software creates new pixels using a mathematical algorithm. It reads the colour values of neighbouring pixels vertically, horizontally and diagonally to calculate the colour of new pixels.

Bleed A print term that describes printing an image, text or colour off one or more sides of a paper sheet leaving no margin or border when trimmed.

Buffer A digital camera's RAM (Random Access Memory), which can store images before they're written to a memory card. The buffer allows the camera to shoot several photos without waiting for each to be saved.

Burst mode A special mode for shooting a sequence of images in rapid succession, useful for taking photos of a fast-moving object. Also known as continuous mode.

CCD (Charge Coupled Device) A light sensor in a camera that records the image you take as a photograph. It consists of millions of tiny light sensors, one for each pixel. The size of CCD is measured in megapixels, and the more there are of these, the better.

CMOS (Complimentary Metal-Oxide Semiconductor) A light sensor that offers higher resolution at a fraction of the cost of a CCD.

CMYK The four process colours used in colour printing: cyan, magenta, yellow and black (K).

Colour cast An unwanted tint of one colour in a photo. It can be corrected with editing software.

Colour correction To correct or enhance the colours within a digital photo.

Compression Digital cameras create huge photo files. To make them more manageable, cameras employ some form of compression such as JPEG. RAW and TIFF files have no compression and take up more space.

Contact sheet Proof sheets containing thumbnails of photos.

Contrast The difference between the darkest and lightest areas in a photo. The greater the difference, the higher the contrast.

Crop A photo-editing term that means removing a portion of a photo.

Depth of field The distance between the nearest and furthest in-focus objects in composing a digital photo. This is changed by altering the aperture. The larger the aperture, the smaller depth of field.

Dialog box A window that appears on the computer screen, presenting information or requesting input from the user. A dialog box is also known as a pop-up window.

Digital zoom Some digital camera can zoom in on the centre of an image by expanding it in the camera. The zoomed area looks bigger but contains the same number of pixels.

DSLR (Digital Single Lens Reflex) The digital equivalent of a SLR camera.

Download The transfer of photos from a camera memory card to the computer.

DPI (Dots Per Inch) A measurement value used to describe the resolution of a display screen or that of a printer. The higher the number, the greater the resolution.

Dynamic range The difference between the brightest and darkest parts of an image. If a shot has very bright highlights, dark shadows and everything else in between, it is said to have a wide dynamic range.

EV (Exposure Value) The amount of shutter speed or aperture adjustment needed to double or halve the amount of light entering the camera.

Exposure Amount of light that hits the image sensor controlled by the shutter speed and aperture.

EXIF (Exchangeable Image File) The file format used by most digital cameras. For example, when a typical camera is set to record a JPEG, it's actually recording an EXIF file that uses JPEG compression to compress the photo data within the file.

External flash A supplementary flash unit that connects to the camera with a cable, or is triggered by the light from the camera's internal flash.

Fill-in flash This is additional light from an external flash, or reflector that is used to brighten deep shadow areas, usually outdoors on a sunny day.

FireWire Technology for transferring data to and from digital devices at high speed. Some professional digital cameras and memory card readers connect to the computer over FireWire. FireWire card readers are typically faster than those that connect via USB.

f-number or f-stop The f-number is the ratio of the aperture of the camera's lens to its focal length. A higher quality lens will have a smaller f-number, which conversely means a wider maximum aperture, and thus more light entering the lens.

Focal length The magnifying power of a lens. The longer the focal length, the greater the magnification.

Full bleed Otherwise known as 'borderless' printing. Means the ink extends to all four edges of a print.

Greyscale A term used to describe an image containing shades of grey rather than colour. Most commonly referred to as a black and white photograph.

⏵ Jargon Buster

Hotshoe A small fitting at the top of some cameras for adding an external flash.

Icon A small picture that represents an object or program.

Image resolution The amount of data stored in an image file, measured in pixels per inch (PPI).

Image stabilisation An optical or digital system built into a lens for removing or reducing camera movement often caused by hand shake.

Interpolation Some cameras and editing software can increase the size of an image by adding pixels between the original ones. They attempt to match the colour and brightness of surrounding pixel to create a seamless image.

Inkjet A type of printer that sprays dots of ink onto paper to create the image rather than paint or laser it on.

ISO (International Standard Organization) In traditional photography, ISO is a measure of the light sensitivity of film, and in digital photography it describes the light sensitivity of the CCD/CMOS. The higher the ISO, the greater the sensitivity.

Jagged edges When you view a digital photo at a high degree of magnification, the pixels that make up the image appear as tiny squares, resulting in straight lines looking jagged.

JPEG (Joint Photographic Expert Group) A file type that is the most commonly used system of digital image compression. It enables a digital camera to squash a large picture into a small amount of memory.

Layers A powerful feature of many photo-editing packages, layers are the digital equivalent to

laying sheets of tracing paper or transparent plastic over the top of a photo. They can be used to add other images, text or special effects to a photo. Stacked onto each other, each layer can be individually edited, positioned and blended with layers below to create a final picture – all without affecting the original photo, which sits at the bottom of the stack.

LCD (Liquid Crystal Display) A monitor often used on the rear of a digital camera to display settings or the photo itself.

Macro mode Often indicated by a little icon of a flower, macro mode helps you take highly detailed close-ups.

Manual mode This provides full control over both aperture and shutter speed, enabling you to alter exposure and depth of field.

Memory card A removable storage device, which holds images taken with the camera. Cards come in a variety of sizes and there are several types including Compact Flash, Multimedia and SD cards as well as Sony's Memory Stick format.

Megapixel A measure of the size and resolution of the picture that a digital camera can produce. One megapixel equals one million pixels.

Metadata Information stored within a digital file. Most digital cameras store photos with extra information as standard and some metadata formats, such as XMP, allow the user to add extra information such as copyright information, captions, credits, keywords, creation date and location or special instructions.

NiMH (Nickel Metal-Hydride) A type of rechargeable battery used by digital cameras that can be recharged many times.

Noise The digital equivalent of film grain. It appears as small, coloured speckles and can detract from picture quality. Noise is worse in digital photos taken in low light.

Parallax An effect seen in close-up photography, where the viewfinder does not see the same as the lens. This is normally due to the offset of the viewfinder and lens.

PDF A PDF (Portable Document Format) is a popular file format that can be opened and viewed using Adobe Reader software. This is usually bundled with new computers or it can be downloaded for free from the Adobe website.

Pixel (Picture Element) These are the building blocks of a digital photo. If you enlarge an image on a computer, you'll see it is made up of tiny squares, which are the pixels. Digital photos comprise thousands or millions of pixels.

PPI (Pixels Per Inch) A measure of the resolution of a computer display on its monitor or digital image.

PictBridge Connect your camera to a PictBridge-enabled printer and you can print your photos at home without using a computer. Almost all cameras have a PictBridge feature.

Point and shoot Term used for a simple, easy-to-use camera with a minimum of user controls.

Program exposures An automatic setting where the camera selects an appropriate aperture setting and shutter speed to get the best performance out of the lens.

RAW format A RAW image file is the data that comes directly from the image sensor of a camera, with no in-camera processing performed.

Red eye This happens when light from the flash reflects off the blood vessels in the subject's retinae, creating a strange red effect that can spoil a photo.

Resample Resampling changes the resolution of an image. For example, if you have a print quality file, you would resample it down to 96 or 72 DPI to post it to a web gallery.

Resolution The more pixels there are in a digital image, the sharper it will appear. This is the resolution, and is often expressed as two figures that represent the photograph's width and height, such as 1200 x 1600 pixels.

RGB (Red, Green, Blue) Every photograph viewed on a computer is made up of varying amounts of these three colours.

Saturation How rich the colours are in a photo.

Self-timer Preset time delay before the shutter fires automatically. This allows the photographer to be in the picture without using a long cable release or remote control.

Sensor Component of a digital camera that uses and captures light as millions of tiny pixels in order to produce the final image.

Sharpness The clarity of detail in a photo.

Shutter button Usually located on the top right of the camera, it's the button that opens the shutter and lets you take your photo.

Shutter speed A measurement of how long the shutter remains open as the picture is taken.

Shutter lag/delay The pause between the time the shutter button is pressed and when the camera actually captures the image.

⊳ Jargon Buster

Slow-sync flash This feature fires the flash just before the shutter closes. It's ideal for night photography to illuminate subjects standing in front of darkened buildings.

Stitching Combining a series of images to form a larger image or a panoramic photo.

Tagging Process of adding descriptive keywords to a piece of information, such as a photo, video or web page, to aid in the search for it.

Telephoto This is the focal length that gives you the narrowest angle of coverage, good for bringing distant objects closer.

TIFF (Tagged Image File Format) TIFF is a lossless file format as the image data is stored whole (nothing is thrown away). This results in large file sizes, but also good quality photographs.

Thumbnail A small version of a photo.

Tripod mount Found on the underside of some cameras, it is a little screw-hole that lets you attach a tripod to your camera.

Unsharp masking The process by which the apparent detail and sharpness of an image is increased.

USB (Universal Serial Bus) A way of transferring data to and from digital devices, such as digital cameras and computers.
Viewfinder The optical window to look through to compose the scene.

Wide angle The focal length that gives you the widest angle of view.

White balance This is a function on most digital cameras that adjusts colour balance to compensate for different colours emitted from various light sources, such as household light bulbs to natural daylight.

XMP (Extensible Metadata Platform) A standard way for embedding information (metadata) in a digital file, most commonly used on photo files.

⏵ Index

index

⏵ Index

Index

Picture Credits
Where there are two or more pictures on the same page, they are from the same source unless otherwise stipulated. Where part of a screenshot, the base image is from the source noted. Screenshots reprinted with permission from Microsoft Corporation and Adobe Systems Incorporated (see page 2).

Courtesy of Digital Vision
Pages 22, 48, 49, 54, 59 (bottom), 72, 76, 124, 125, 131, 179

Courtesy of iStockphoto
Pages 12, 19, 57 (bottom), 65, 73, 77, 81 (bottom), 83 (top), 85, 89 (top), 126, 127, 166, 167, 168, 169

Courtesy of PhotoDisc
Pages 14, 51, 57 (top), 58 (bottom), 59 (top), 69, 86, 87, 109, 128, 129, 130, 142, 143, 146, 147, 150, 151, 152, 153, 154, 155, 156, 157, 158, 159, 160, 161

Courtesy of Shutterstock
Pages 13, 18, 21 (top), 28 (bottom), 29, 30, 34 (bottom), 35, 47, 50 (bottom), 58 (top), 60, 62, 63, 64, 71, 74, 75, 79, 81 (top), 82, 83 (bottom), 84, 88, 89 (bottom), 90–1, 91, 92, 99, 116, 162, 163, 164, 165, 170, 171, 172, 173, 174, 175, 176

Courtesy of Lynn Wright
Pages 23, 38, 40, 41, 42, 44, 45, 50 (top), 61, 66, 68, 78, 80, 96, 97, 98, 107, 118, 119, 120, 122, 132, 133, 134, 135, 136, 137, 138, 139, 140, 144, 145, 148, 149, 198, 201, 202, 208, 209, 211 (bottom), 212, 213

All other images from the Which? website

ABOUT THE CONSULTANT EDITOR LYNN WRIGHT
Lynn Wright is an editor and journalist with 20 years' experience in writing about computing, technology and digital photography.